FIT

Rikki Beadle-Blair

FIT

Screen & Stage Plays

with Teachers' Notes for England, Wales and Scotland

OBERON BOOKS
LONDON

First published in 2010 by Oberon Books Ltd
521 Caledonian Road, London N7 9RH
Tel: 020 7607 3637 / Fax: 020 7607 3629
e-mail: info@oberonbooks.com
www.oberonbooks.com

A catalogue record for this book is available from the British
Library.

ISBN: 978-1-84943-080-7

Front cover images by Ed Swabey from the original
cinematography by Patrick Smith.
Back cover images by Rikki Beadle-Blair.
Product support by Adidas.

Cover Design by James Illman

Printed in Great Britain by CPI Antony Rowe, Chippenham.

Contents

Introduction 7

FIT Screenplay 11

FIT Stageplay 113

Teachers' Notes: England & Wales 169

Teachers' Notes: Scotland 185

For Joni

who loves to learn and who taught me so much

Introduction

When I was asked to write a play on homophobia for schools my heart sank. Surely this was a step down at this stage in my career? Well, as soon as I realised I was being such a snob, I knew – not only did I need to write and direct this play, but I needed to be in it and go on tour with it and run the workshop to boot. So I did. And it was life-changing. Over three winters we toured up and down the country, performing for about 20,000 people – and every show in every school, theatre and youth club I learned something new. About education, about sexuality, about human psychology, about who we are. I learned that everyone we meet is in some way or another our superior, and that everyone has something to teach the world. Every day I was challenged, stretched and inspired. Every show made me want to think more, feel more, work harder. Every event and encounter made me vow to get better.

I wrote the play in my usual way – casting first, letting the actors choose the name and background of the character. I then started writing in instalments, as we rehearsed, blocking as the new pages were born and rewriting on the hoof until the play was finished. But *Fit* was one of the hardest plays I've ever had to write, three false starts before I really got going. I couldn't have swearing – so how did I make the language reflect the way young people really speak and avoid having them dismiss our approach as 'soft'? How do you show bullying honestly without glorifying it? How do you represent a wide range of sexuality with a small cast? How do you create something educational without being preachy? And how do you do it all in under an hour?

I knew the play had to work on several levels. It had to be a show that people as young as 11 could enjoy when it was staged in a school hall, and that adults could appreciate in the theatres we played in. It was crucial too that teachers could engage with the project; that it offered them assistance and inspiration when it came to tackling the thorny issue of sexuality and bullying. We offered different jokes for different folks. This seemed to work,

and we found ourselves experiencing a very different show in the daytimes from the evening.

Street dance was a key element in making *Fit* a success. It's cool, it's visually striking – it's popular with both straight and gay kids – but it can open you up to accusations of being 'gay'. It was a perfect bridge device for this subject. And it worked. Throw in some cool retro tracksuits and bam! I had theatre that would make a jaded, resistant audience sit up and engage as soon as they walked in to find us limbering up on our big chequer-board street-dance mat.

Secondly, humour was crucial. Everyone was expecting a dry finger-pointing piece. The humour took the preachiness out of it, loosening us all up so that we could engage with the heavier elements.

The hour-long workshop that topped and tailed the drama was as exhilarating as doing the performance. Daily, we would find ourselves taking a roller-coaster journey with our audience out of a dark and heavy distrust and disapproval of diversity and into a light, lively atmosphere of open-minded, honest debate and a shared enlightment about the variety that our humanity has to offer. It left me breathless.

Something special was happening – and I knew it couldn't stop there.

There had to be a film. And four years after the play was first discussed, it all came together and I started to write the screenplay. The challenges were greater but so was the scope – I could have so many more characters and show a much broader range of attitudes. I was free. Using only a handful lines from the original stage play I wrote the entire screenplay in two weeks.

The touring experience proved invaluable. Up and down the country we had encountered the same questions and concerns about sexuality again and again – "If my friend is gay, won't they try and 'jump' me?" "What would we have in common?" "Isn't gay a crime against God?" "If everyone is gay, won't the human race die out...?" I could pick up on and respond to all these issues in the script.

Directing the actors was made so easy. The main actors had already performed these characters for over 20,000 people and

held countless workshops. We knew exactly how teachers and pupils interacted around these issues, and we could bring all our observation of their behaviour to the film-set with us.

Film is so much more about what you show and not what people say. I could add layers of emotion and characterisation with a look or a reaction shot; with the detail of the sets and costumes. I could go deeper faster. Theatre is immediate and exciting – the characters are right there in the room with you – and in this case, they could be questioned and directly challenged. But film is faster and more focused and can be watched over and over. It's been a fascinating privilege to work on the project in both mediums.

And now it's published. People will be able to discuss the jokes, uncover the layers, interrogate my intentions. I am so excited that people will have the chance to put on their own productions of *Fit* – with their own choreography and interpretations of the dialogue and action - use speeches for auditions or even film sections for projects. I can't wait to see someone else's version of *Fit*. I hope it's as inspiring, enlightening and liberating an experience for others as it has been for me.

'Fit – the movie – the Movement' and 'Team Angelica – get involved' are both on facebook

Please feel free to contact Rikki directly through Rikki@ teamangelica.com

FIT SCREENPLAY

Based on the stage play *FIT* developed and produced by Queer Up North, Stonewall, The Drill Hall Theatre, Homotopia Liverpool and Team Angelica.

Cast (in order of appearance)

TEGS	Duncan MacInnes
JORDON	Ludvig Bonin
KARMEL	Sasha Frost
LEE	Lydia Toumazou
RYAN	Stephen Hoo
ISSAC	Jay Brown
LORIS	Rikki Beadle-Blair
LUCA	Alexis Gregory
JACEK	Andy Williamson
PRINCIPAL BAILEY	Donovan Cary
CHARLIE	Jack Shalloo
NINA	Ambur Khan
TYLER	Jason Maza
MOLLY	Katie Borland
TISH	Alicia Jones
ARISTOS	Alex Papadakis
MARIOS	David Chrysanthou
JAMIE	Tom Ross-Williams
KIM	Jennifer Daley
KELI	Dani Bright

JONAS	Vincent Williams
VANDER	Richard Tan
DARCY	Davina Dewrance
ALEX	Tigger Blaize
CHARLOTTE	Rachel Lynes
ETHAN	Marcus Kai
KARMEL'S DAD	Gary Beadle
KARMEL'S MUM	Jo Castleton
STRAIGHT BLOKE	Dann Kharsa
STRAIGHT GIRL	Hannah Chalmers
BUS STOP RITA	Samantha Lyden
TEGS' MUM	Jeanette Rourke
LINUS	Ryan Quartley
JORDAN'S MUM	Janine Stride
JORDAN'S DAD	Matt Ray-Brown
TOBY	Kyle Treslove
JONESY	Michael Warburton
RYAN'S SISTER	Helen Russell-Clark
RYAN'S DAD	Chooye Bay
DITA THE DOG	Winnie Walker

DANCE & DRAMA

INT. BEDROOMS — DAY

MUSIC.

WE ARE THE MIRROR – We see all the main teenage CHARACTERS

TEGS, JORDAN, KARMEL, LEE, RYAN, ISAAC – trying on clothes and discarding them

CAST: Gay....

> *(Change.)*

> Gay....

> *(Change.)*

> Gay....

> *(Etc.)*

> *LEE stomps off-camera, revealing a bomb-site bedroom...*

LEE: Muuuum! Does this look gay?

EXT. OUTSIDE SCHOOL — DAY

LORIS (Black, dreadlocked, sporty – 40's) hops out of the passenger seat of LUCA'S (Half-Italian, funky late 20's) CAR.

LORIS: Do I look gay in this?

> *LUCA checks out LORIS'S outfit.*

LUCA: Yes.

LORIS: ...Good.

> *They smile, LUCA drives away – LORIS steps through the gate and BAM! is knocked aside by running ISAAC (17, short, half-Polish,*

cheeky) who is being hotly pursued by JACEK. Suddenly RYAN (17, wiry, Anglo-Chinese,) comes flying up behind and onto JACEK'S back...

LORIS: Oy

RYAN: Get off him! Leave him!!

LORIS: Oy! Oy, oy, oy!!! Okay, okay, okay – break it up!

ISAAC: Knob!

JACEK: Faggot!

ISAAC: Loser!

RYAN: He ain't the faggot – you're the faggot!

PRINCIPAL BAILEY: Gentlemen!

The fight stops mid-punch – ISAAC, JACEK and LORIS all staring at the PRINCIPAL BAILEY, panting.

PRINCIPAL BAILEY: Are we quite finished?

ISAAC/JACEK: He started it!

PRINCIPAL BAILEY: *(To ISAAC.)* Mr Chmara – I believe you have a appointment at my office...

(To JACEK)

And Mr Chmara – I believe you have an exclusion order?

JACEK throws the PRINCIPAL BAILEY a fiery look, then leaves, throwing ISAAC one last sly blow. ISAAC lashes back.

ISAAC: Come off me! Fool!

PRINCIPAL BAILEY: Mr Chmara. Mr Wang...

RYAN: It Wong, man...

PRINCIPAL BAILEY: will show you the way.

RYAN & ISAAC looks at PRINCIPAL BAILEY resentfully.

PRINCIPAL BAILEY: I'll catch you up.

RYAN & ISAAC sets off. LORIS picks up the spilled contents of his backpack.

LORIS: Brotherly love?

PRINCIPAL BAILEY: Sadly not …Father and son.

LORIS looks at the track-suited young man loping off like a teenager…

PRINCIPAL BAILEY: You're new.

LORIS: …How can you tell? I'm the replacement drama teacher.

PRINCIPAL BAILEY: Ah.

LORIS: As in 'Oh dear'?

PRINCIPAL BAILEY: As in good luck.

They shake hands.

INT. BOY'S TOILET — DAY

JUMPCUT THRU TEGS (wide-eyed, gentle, 17, white) in TOILET CUBICLE, trying to stop his nose bleeding. He throws wad after wad of bloody paper into the toilet bowl. It won't stop.

His phone is vibrating. He struggles to find it while keeping his head tilted back. He answers it…

TEGS: Sorry, man.

EXT. COLLEGE PLAYGROUND — DAY (INTERCUT)

JORDAN (17, athletic, African descent) is juggling a football, while on the phone.

JORDAN: Yo, where you at, man?

TEGS: Toilets.

JORDAN stops juggling.

JORDAN: Toilets?

TEGS: Sorry...

JORDAN moves swiftly towards the college building...

JORDAN: Everyone's going in. We're late.

TEGS: I know... sorry.

JORDAN is taking the stairs three at a time.

JORDAN: ...You alright?

TEGS: I'm sweet. I'll be down in a minute...

JORDAN is shoving the BOY'S TOILET DOOR open... TEGS hears the door and closes his eyes. JORDAN bangs on the cubicle door. TEGS opens the door, JORDAN sees the blood.

JORDAN: Who done that?

TEGS: It's just a nosebleed.

JORDAN: Another one?

(Reaching out...)

It's all over your face!

TEGS: You know what I'm like... I think it's stopped...

JORDAN hand catches TEG'S nose.

JORDAN: Oh, Ra! Sorry, man!

TEGS: Ah! Jordan, man!

(Holds a hand up.)

...it's stopped...

JORDAN peers at TEGS. TEGS sneezes – whoosh – JORDAN'S face is covered in blood. They stare at one another, stunned. TEGS giggles, JORDAN giggles, they start to laugh.

INT. DANCE AND DRAMA ROOM — DAY

LORIS stands looking round in a wrecked room.

EXT. BUS STOP. DAY

LEE (17, petite, Anglo-greek tomboy) sits listening to her ipod – waiting. She checks her phone. A bus pulls up LEE sits up as people flood off – looking for someone. She asks a passing STRANGER something... They show their watch... The bus pulls up and KARMEL (17, pretty, mixed-race) gets off, attempting breeziness.

LEE: I been waiting, man.

KARMEL: I tried to text...

LEE: At the usual stop. Forty minutes.

KARMEL: I run out of credit. Wanna Chupa-chup? What?

LEE: I can't believe you darked me out for some boy.

KARMEL: What boy?

LEE: Go on, blatantly lie – He better be well fit.

KARMEL: Lee! There's no boy!

LEE: WhatEVER! Raaa... Keep your weave on...

KARMEL: This ain't a weave! Why you being so gay?

LEE: *(Wounded.)* Why are you being so gay? Where's that chupa chup?

KARMEL marches ahead...

LEE: Oh, So I'm the bad friend, is it? WhatEVER!

INT. LUCA'S ART STUDIO/DANCE AND DRAMA ROOM — DAY

LUCA answers a call from LORIS – who tidies as he talks.

LUCA: Don't tell me you've been fired already.

LORIS: That's not for at least another ten minutes.
We haven't started yet. I can't believe this is happening to me all over again. My first day at school and I'm worried about the kids calling me names.

LUCA: You'll be fine... Just be yourself.

LORIS: Thanks mum. You always know what to say.

INT. PRINCIPAL BAILEY'S STUDY — DAY

JUMP CUT THRU two different meetings – RYAN and ISAAC fidgeting in their seat, shifting – scratching – gazes out of the window... RYAN plays with the football in his hands.

PRINCIPAL BAILEY: ...Ryan…? ...Ryan…? Isaac? Mr Chmara? Mr Leung?

ISAAC and RYAN looks around – the PRINCIPAL BAILEY drifts into focus...

PRINCIPAL BAILEY: ...have you heard a word I've been saying to you...?

ISAAC: *(Defensively.)* Yeah...

PRINCIPAL BAILEY: Okay... what was I saying?

RYAN: ...I'm expelled?

PRINCIPAL BAILEY: I was saying that you're on your last chance. I was saying that if one more teacher feels compelled to exclude you from their classes – then you will have nowhere left to go – except home – permanently.

RYAN shrugs.

PRINCIPAL BAILEY: You get me?

ISAAC shrugs.

PRINCIPAL BAILEY: Isaac...? Ryan...?

RYAN: You're making me late.

PRINCIPAL BAILEY: You were late anyway.

RYAN: You're making me later, innit?

ISAAC: You gonna give me a note for teacher?

INT. CORRIDOR/DANCE AND DRAMA ROOM — DAY

LEE & KARMEL are peeking through the glass in the doorway...

LORIS is standing in the centre of small sullen STUDENT circle including CHARLIE, NINA, TYLER, MOLLY & TISH.

LORIS: I'm gonna need help remembering your names – So what we're all going to do is give our names – and make a gesture that goes with it that says something about who we are, okay?

 (Joining the circle.)

 I'm...

 (Smiley face gesture.)

 Loris.

 LORIS turns to NINA – She looks down at the ground...

LORIS: Your turn…?

NINA: Someone else first...

LORIS: ... next?

 Silence.

LORIS: ...Anyone want to go first?

TYLER: (*17, Good Looking, White.*) We know each other's names.

LORIS: I don't know your names.

CHARLIE: *(17, Lanky, Anglo Irish.)* That's your problem, innit?

LEE: We should go in.

KARMEL: You first, yeah?

LEE: You first – you made us late!

RYAN: Tension in the lesbian community?

LEE and KARMEL turn to see RYAN and ISAAC.

KARMEL & LEE: Die, Ryan.

They turn away. JORDAN and TEGS come down the hallway...

RYAN: Oh, what a put down! I am so wounded – I don't know if I'll ever recover...

JORDAN: You're in the way.

ISAAC: Don't waste your time checking out the new drama teacher – he's even gayer than you are.

JORDAN: Could you lot come out the way, please?

RYAN: Was he the one from earlier? Blatant bumjumper!

ISAAC: Batty Riderrr!!!

JORDAN: *(Shoves ISAAC.)* Move!

ISAAC and RYAN are pushed into the room.

LORIS: You're late.

(Turning back to CIRCLE.)

Actually, your problem is that you don't know me. I don't know happened to your last drama tutor – you clearly wish to give the impression that you killed, cooked and ate them – but I am not them. My name is Loris *(Smiley face gesture.)* I love to teach and I love to learn and my class is not a doss to get a credit, 'cause I will fail anyone who's late or who does not participate. If you don't want to learn and have nothing to teach me, you should drop out now. If you do not think you will thrive in an atmosphere

of mutual respect you should drop out now – and if you do not love drama, dance you should leave now.

Silence. Then the entire class picks up their bags and goes, leaving TEGS, JORDAN, LEE, KARMEL, ISAAC and RYAN.

CUT TO:

INT. DANCE AND DRAMA ROOM — DAY (5 MINS LATER)

LORIS: My name is... *(Smiley face.)* ...Loris!

LORIS looks at KARMEL.

KARMEL: *(Sighs.)* My name is...

(Miming make-up.)

...Karmel.

LORIS smiles – KARMEL shoots back a sarcastic grin, but is a little pleased with herself.

LEE: My name is...

(Miming basketball.)

...Lee.

LORIS: You're the school netball queen, yeah?

LEE: Basketball.

ISAAC: *(Fake sneeze.)* Dyke!!

LORIS: Pardon me?

ISAAC: *(Looking round in mock surprise.)* Bless you.

(Fake cough.)

Gay!!

('Apologetic.')

Sorry... Hayfever.

LORIS: How about you go next?

ISAAC: Me, sir?

LORIS: You sir.

ISAAC: My name is...

> *(Miming a fart.)*

> ...Isaac.

> *RYAN and ISAAC crack up – falling about laughing. Everyone else watches them stone-faced.*

LORIS: Who's next?

> *LORIS looks at TEGS – who shoots back a nervous look.*

JORDAN: *(Jumping in.)* My name is...

> *(Mimes an elaborate football trick.)*

> ...Jordan.

RYAN: My name is...

> *(Mimes an even more elaborate footie trick.)*

> ...Ryan.

TEGS: My name is…

> *(Startlingly skilful tap move.)*

> Tegs.

> *Everyone is stunned into silence for a moment.*

LORIS: You tap-dance?

TEGS: Sort of.

LORIS: 'Sort of?' Do you dance any other styles?

RYAN: *(Under his breath.)* Aaaaaabsolute homosexual!

JORDAN: You what?

RYAN: You what?

JORDAN: What did you say?

RYAN: What did you say?

JORDAN: If you got something to say, speak up –
 what?

 (Kisses his teeth.)

 Waste, man....

RYAN: *(Under breath.)* Least I ain't gaaaaay...

 JORDAN moves forward.

JORDAN: Come closer and I'll show you who's gay, yeah?

LORIS: How about we play a game called 'lets not get
 expelled?' I will say each of your names – you will show
 us why you've been kicked out of every other course and
 ended up here. And we won't lie – because having to lie is
 even sadder than making a mistake.

LEE: How will you know if we lie?

LORIS: I'm a witch. You're first.

LEE: Me?

LORIS: Yeah thee – Lee – who was kicked off of her last course
 because she...

 LEE falls to the ground and pretends to be asleep.

LORIS: ...fell asleep in class!

 (Clapping and laughing.)

 Excellent! Clear, concise, believable –
 Perfect! You next!

 ISAAC spits on the floor.

OTHERS: Urrrr!

LORIS: Charmed! Ryan!

RYAN give LORIS the finger...

LORIS: Sweet! Karmel!

KARMEL mimes texting...

LORIS: Nice! Jordan?

JORDAN kicks a chair across the room.

LORIS: Sociable... Tegs!

TEGS walks out and slams the door hard. There is a moment, then he peeks back round the door with a shy smile...

LORIS: Diva! Give yourselves a round applause!

LORIS applauds. One by one LEE, KARMEL, JORDAN ISAAC, RYAN, and finally TEGS join in applauding themselves...

ISAAC: ...this is soo gay...

LORIS: Yes, it's so gay, so we're going to take off our gay hoodies and get ready to sweat some...

ISAAC: We ain't gonna dance are we?

LORIS: Yes. To Shakespeare.

KIDS groans...

LORIS: Don't tell me you lot don't like Shakespeare, I am shocked and surprised. What don't you like about him?

LEE: It's boring.

RYAN: It's gay.

TEGS: Too slow.

ISAAC: Too white.

KARMEL: I can't understand anything anyone's saying...

LORIS: But you speak Shakespeare all the time.
Heard of the green eyed monster?

LEE: Jealousy, yeah.

LORIS: Shakespeare said it first. 'Good riddance'?

JORDAN: Shakespeare made up 'Good riddance?'

LORIS: 'A charmed life' – 'heart on my sleeve' – 'Mum's the word' – 'in the twinkling of an eye' – 'in a pickle' – 'make your hair stand on end' – 'more fool you'...

JORDAN: ...All Shakespeare?

LORIS: ...all Shakespeare. You speak Shakespeare every day...

ISAAC: Shakespeare's still gay.

LORIS: ...And he was gay. Well done, Isaac. I'm impressed.

ISAAC: I didn't mean gay like you're gay – I meant...

LORIS: I'm listening...

ISAAC: I meant like gay like as in...

LORIS: As in...?

ISAAC: You know – gay.

LORIS: I don't know. Help me.

ISAAC: You know...

RYAN: Sir – You know he just called you gay, yeah?

LORIS: Can't sneak anything past you, can we, Ryan?

RYAN: And you don't mind?

LORIS: Why would I mind?

LEE: So, you are gay?

LORIS: I'm not sure what you mean by gay anymore, you all say gay so often...

RYAN: ...As in homo...

LORIS: Oh, as in homosexual! Yeah.

RYAN: You admit it?

LORIS: Why wouldn't I?

LEE: And Shakespeare's gay an' all?

LORIS: I was shocked too – who knew there were two of us?

LEE: How do you know Shakespeare was gay?

LORIS: Well, we don't know... for certain...

KIDS: Aahhhh!

LORIS: ...But! he wrote 123 Sonnets to a 'fair youth' – a beautiful young man. If he wasn't actually gay, he didn't care if people thought he was. He had a gay heart.

TEGS: A gay heart?

LEE: What's a sonnet?

TEGS: It's a type of poem.

RYAN/ISAAC: Oooooohhhh!

TEGS: *(Blushing.)* Leave it out... How can you have a gay heart?

ISAAC: Well, if you don't know, who does?

KARMEL: So, how you gonna dance to Shakespeare?

LORIS: I was wondering when you were gonna ask! Shakespeare – the Gay genius – is all about rhythm. Life is rhythm. It takes rhythm to walk. It takes rhythm to breathe – for your heart to beat – for your blood to pump – for your lips to drum out the sounds that tell us what you're thinking and what you're feeling. Shakespeare is a slang. If you showed your mum Kidulthood with people goin' 'Oi, my size!' They'd be like, 'what are they talking about? What does "Low dat, fam, She's stush! Dere's this gyal round my enz what's proper buff and she's got a friend who is well peng – how bout we bounce and go and check the runnins at her yard, you know what I mean?"

...mean? All language is slang – all language is poetry – all movement is dance.

LORIS goes to the window

LORIS: Check it out...

Reluctantly the KIDS go to the window and look down at people moving around the school grounds...

We see in MOLLY in a hurry, checking her watch...

LORIS: '...I'm in hurry.'

TISH dragging her feet and sighing...

LORIS: '...I'm bored...'

NINA slinking along on the phone...

RYAN: 'I'm sexy...'

...CHARLIE swaggering, hoodie up...

LORIS: 'I'm street'. Everyone is dancing and singing every moment of the day – making statements, shouting out here I am and this is how I feel – telling you their story – it's all dance and drama.

LORIS: To be or not to be – that is the question...

LORIS turns on the music.

LORIS: To be or not to be – that is the question.

LORIS beats on his chest in rhythm with the words... Each person picks it up one by one until they are all joined in... LORIS turns to the mirror and makes a move – they start to copy that – he adds steps – until they have a ROUTINE... STUDENTS including CHARLIE, TISH, NINA, TYLER and MOLLY start gathering outside the door to watch... The routine builds – and ends.

LORIS, JORDAN, LEE, KARMEL, TEG, RYAN and ISAAC whoop and cheer, bowing and waving to their audience – EVERYONE at the door moves away tries to look cool and disinterested.

LEE'S STORY

EXT. LEE'S FRONT YARD — DAY

LEE is playing basketball with her brothers – while dialling her phone – she listens to it ring at the other end…

INT. KARMEL'S BEDROOM — DAY (INTERCUT.)

KARMEL is doing her hair. She picks up the flashing vibrating phone – She puts it down… Then snatches it up at the last minute and answers.

KARMEL: Sorry, I was in the shower.

LEE: My psychotic mother's cooking so she's probably gonna force me to eat – meet you in an hour at the rendezvous?

 Silence.

LEE: *(Stops playing.)* Karmel!!!

KARMEL: Lee, I'm sorry…

LEE: Go on, lie to me and say it ain't a boy, I dare you.

ARISTOS: Course it's a boy!

MARIOS: Aristos…

LEE: Shut up!

 (To K.)

 Not you – my ugly brother.

ARISTOS: Of course she's seeing a boy and not you, 'cos she's normal!

MARIOS: Aristos!

LEE: *(Shoving ARISTOS.)* Die! Karmel… Why you being so gay?

KARMEL says nothing...

LEE hangs up.

ARISTOS: She hang up on you? Oh my days, man! Shame! You want us to go round and beat her up?

LEE sits on the doorstep. MARIOS sits beside her. He puts his arm round her.

MARIOS: Maybe you should wear your hair down sometimes... You got wicked hair. Just act a bit more... average... you know what girls your age are like. They worry what people think.

LEE: What you saying? Karmel's ashamed of me?

MARIOS: I'm just saying it wouldn't kill you to wear a skirt once in while.

LEE: Are you ashamed of me?

MARIOS: ...No.

LEE: Let go of me.

MARIOS: Lee...

LEE pulls away from MARIOS and storms off into the house.

ARISTOS: Now that's a man hater!

MARIOS: *(Rejoining the game.)* 'Low it, man.

ARISTOS: Can't even stand to touch her own brother!

INT. LEE'S BEDROOM — DAY

JUMP-CUTS

LEE crying.

LEE looking in the mirror, letting her long hair loose.

LEE looking out of the window.

P.O.V. LEE. MARIOS and ARISTOS playing basketball, laughing, shoving – a DANCE of unconscious masculinity.

EXT. STREET OUTSIDE KARMEL'S HOUSE — NIGHT

LEE, bundled up in her hoodie, waiting astride her bike...

A CAR pulls up outside KARMEL'S HOUSE and the HORN blows –

LEE watches as KARMEL hurries out the house and JAMIE gets out of the car to greet KARMEL with a kiss and a hug.

KARMEL and JAMIE get in the car and it pulls away...

LEE cycles after it.

EXT. LONDON STREETS — NIGHT

LEE pedalling furiously in pursuit of JAMIE'S car.

EXT. STREET OUTSIDE YOUTH CENTRE — NIGHT

JAMIE'S CAR pulls up outside the YOUTH CENTRE. LEE cycles breathless up the street in time to see KARMEL and JAMIE getting out of the car and approaching KIM who greets KARMEL with open arms, and kisses her...

then kisses her again and again...

LEE stares in stunned surprise.

KIM takes KARMEL by the hand and leads her into the YOUTH CENTRE.

INT. YOUTH CENTRE (GAY YOUTH GROUP MEETING.) — NIGHT

LEE watches through the window as KARMEL sits in a DISCUSSION group.

KELI is pulling papers out of a hat.

KELI: First Question: 'When did you first know?'
Okay – I knew when I was about nine and I was watching
Xena Warrior Princess...

JONAS: Who's Xena warrior Princess?

GIRLS: What?!!!!

JUMP-CUT THRU.

JONAS: I was six.

VANDER: I was thirteen...

DARCY: I was eight. With me it was all about Buffy.
General reaction...

DARCY: Willow and Tara – Oh my God – Willow and Tara!
Am I shaking?

JONAS: Who's Willow and Tara? Who's Buffy?

PAPER CUPS are hurled at JONAS.

ALEX: I knew in the womb. I wasn't born – I was a pride
parade – Pink balloons in the delivery room – dykes on
bikes – rainbow nappies – the lot!

JAMIE: Like... Six months ago?
(Skeptical reaction.)

JAMIE: Seriously! I thought I was a metrosexual!
My mates used to say I was 'a bit of a Beckham'. Then I
realised I wasn't after Posh, I was Posh. Posh with a penis.

VANDER: ...But I never knew I was gay. I just knew I was in
love.

CHARLOTTE: I thought I was straight. I knew I was straight.
It was just a crush – then it was just a phase – then I was
curious, then all the way gay – I was a closet bisexual. 'Out'
and still hiding. And then I saw Milk. The film? With
Sean Penn. And there was this one female character – this
one gay girl – making history – and I thought 'What am I

doing? I'm cooler than this.' This isn't a phase. This is me. Making history.

KIM: I always liked boys. Talking to 'em.
Hanging out with 'em. I just never wanted to kiss one.

We move round to KARMEL.

KARMEL: I think I've always known. All my life, I've always known. Never done anything. Never had any real crushes. Pretend ones – checking out boys with my best mate, filling out questionaires in magazines together about our ideal man. Pictures on my bedroom wall. Nothing real. But I've always known... and never said. ...I'm gay.

LEE'S face at the window. Staring.

INT. DRAMA AND DANCE STUDIO — DAY

KARMEL, RYAN, TEGS, JORDAN, ISAAC, watch LORIS as he breaks down the dance routine... LEE watches KARMEL. CHARLIE, TYLER, AMBUR and TISH stand in the doorway watching.

LORIS: Okay, I've got a new move for you – you're gonna love this... "Oooh,"

(Miming girls curves.)

"Sweetform!"

Laughter – boys cheer...

LORIS: ..."Take my number!" See, I've been watching you!
Now you –

CLASS: "Ooh Sweetform! Take my number!"

LORIS: And now - for the ladies...

KARMEL: Thank you!

LORIS: ...and who-ever – I live in hope... "Oooh!"

(Miming boys muscles.)

"Chiseler! Take my number!"

RYAN/ISAAC: Naaaah man! 'low that!

LORIS: 'Low that? 'Low this! Together!

CLASS: "Ooh, Chiseler!"

RYAN/ISAAC: "Sweet form!"

CLASS: "Take my number!"

LORIS: *(To the faces at the door.)* Are you lot auditioning to be draft excluders or are you going to join in?

TISH: We want to, sir, but...

CHARLIE: ...We don't want to be gay.

RYAN/ISAAC: You what?

FISAAC: What you sayin' man?

RYAN: You saying we're gay?

CHARLIE: *(Pointing at LORIS.)* You said he's gay.

NINA: They said you're gay, sir.

LORIS: Yes, but I'm very open-minded, and I really don't mind if you're not.

LEE looks at KARMEL, who sees her looking and turns away.

AMBUR: So we can come in then?

LORIS: Welcome back, ladies...

AMBUR and TISH hurry in and put their bags down...

LORIS: *(Smiling.)* ...you're late.

(To TYLER and CHARLIE.) Well?

TYLER and CHARLIE look at each other...

LORIS: I promise no one will rub up against you to make you catch the gayness.

LEE runs from the room...

KARMEL-OLIVIA/LORIS: Lee!

RYAN/ISAAC: Gay!

NINA: Lesbiannnnn!

KARMEL: Shut up!

KARMEL goes after LEE.

INT. HALLWAY — DAY

KARMEL goes to hug LEE... LEE tries to pull away, but dissolves into her best friend's arms...

KARMEL: Lee, what's wrong?

LEE: I'm not gay.

KARMEL: What?

LEE: I'm not gay.

KARMEL: What are you talking about?

LEE: I'm not gay and I'm not funny or clever or cool and you're darking me out to be with your new friends and talk about gay stuff and be gay together and you're my best mate and I love you! I mean, I don't love you, but I love you and don't want to lose you – but I have.

KARMEL: Don't be mental. You haven't.

LORIS pops his head out of the studio.

KARMEL: Sorry, Sir – we'll be there in a minute.

MOLLY approaches.

MOLLY: Mr Dawes... can I speak to you a minute, please?

LORIS lets MOLLY into the class.

LEE: I followed you. I spied on you. I'm a bad person.

KARMEL: No you're not.

KARMEL hugs LEE...

KARMEL: You're just a bit mental.

EXT. OUTSIDE LEE'S HOUSE — NIGHT

LEE is waiting on the pavement.

JAMIE'S CAR pulls up at the kerb.

LEE: Jamie?

JAMIE: Lee?

LEE gets in the passenger seat.

JAMIE: Karmel said you were cute!

LEE: Me?!

JAMIE: Don't worry...

(Winks.)

...you're safe.

JAMIE drives off.

ARISTOS and MARIOS, frozen mid-basketball game – stare...

EXT. OUTSIDE KARMEL'S HOUSE — EVENING

JAMIE'S CAR pulls up to KARMEL on the KERB – LEE sticks her head out of the window...

LEE: Alright, darlin'!

EXT. STREET OUTSIDE YOUTH CENTRE — NIGHT

KARMEL is kissing KIM hello, LEE doesn't quite know where to look...

KIM: Hi!!! Ohhhh! you're so cute!

KIM hugs LEE, then grabs her hand to drag her indoors.

KIM: Everyone is dying to meet Karmel's infamous Lee.

INT. YOUTH CENTRE (GAY YOUTH GROUP MEETING.)
– NIGHT

JUMPCUT THRU; KIM introduce LEE to the GAY YOUTH GROUP.

KIM: You're sitting next to me!

KIM goes to grab a chair.

KARMEL: She's nervous. It's cute.

KELI pulls a note from the hat – reads…

KELI: When and how did you first come out?

LEE looks at KARMEL…

KIM: Its when you tell someone your gay.

LEE: I know.

KARMEL: Last week. Here. To you.

JAMIE: Six months ago to my best mate – He was drunk
– so the next day he couldn't remember – he was like – I
dreamt last night you were a bender – I was like – I've had
the same dream about you for the last five years!

VANDER: The first thing my mother said was don't tell your
father.

ALEX: I came out to my dad first. He's in the police force – it
was definitely gonna be tricky – he said 'Gay? 'Like your
grandad?' I said 'Grandad wasn't gay!' I mean Grandads
aren't gay, right? He's like, you know your great uncle
Simon? I'm like 'he wasn't my great uncle?' Dad's like –
only by marriage. Apparently they had a private ceremony
in 1978! I felt totally upstaged!

ETHAN: It was at my sister's Wedding. It literally just 'came
out' – My mum was talking about me having a wedding

one day and I said 'civil ceremony.' And she said 'What'? And I explained that gay people can't get married and that we have to have civil partnership and she was really quiet and then she says: 'As long as I get to wear a new hat.'

JONAS: I told my mum when she was cooking and she burned herself. Drama. My mother loves drama – she's the biggest queen I know.

VANDER: Mine keeps talking about grandchildren. I said you've got seven! She says you have to have kids or you'll be lonely.

I said, 'I've got to have a boyfriend or I'll be lonely.' I had a girlfriend when I was 14. I've never been so lonely.

JONAS: She keeps saying 'but you don't look gay!' I think she wishes I was a tranny – then we could be 'girlfriends'. I'm the wrong kind of gay.

CHARLOTTE: Oh, don't worry – I'm the wrong kind of gay too! I go to clubs and they won't let me in!
Apparently lesbians aren't supposed to be girly. I have to come out every day.

KIM: You need a gay passport…

CHARLOTTE: Lesbian I.D.! I've come out, now can I come in?

LEE puts her hand up…

KELI: Lee?

LEE: What's a tranny?

KIM: It's short for transgender.

KELI: Someone who crosses the traditional boundaries of male and female.

DARCY: Ah! I know this! Transexuals are people who change sex – Transvestites are people who dress up as the opposite sex… And drag queens and kings dress up for a living.

LEE: Has anyone got a pen? I think I need to take notes.

KELI: Here....

LEE stretches for a pen from KELI, KIM whispers to KARMEL…

KIM: So cuuuute!!!

JUMPCUT THRU LEE taking notes.

LEE: So, what's a transexual?

CHARLOTTE: Boys who feel more like girls or girls who feel more like boys...

LEE: Transvestite?

KELI: They're content with their born gender but feel the need to wear clothes of the opposite sex.

LEE: So – am I a transvestite?

KELI: No. Lots of girls are tomboys when they're young and they grow out of it.

ALEX: I didn't. I'm a total boy and I love it.

KELI: I'm not a boy. I like being a girl.

ALEX: And that's cool too.

KELI: There're as many ways to be a girl as there are girls.

KARMEL: That's yours.

LEE: Ok... what's a civil partnership?

ETHAN: Like marriage for gay people.

ALEX: But we mustn't call it marriage!

KIM: Straight people go mental!

JAMIE: Not all of 'em.

KELI: Gay people can't get married in church.

DARCY: Who wants to get married in a church anyway?

VANDER: Me!

CHARLOTTE: It would be nice to have a choice.

ETHAN: I kind of like having our own thing.

DARCY: I agree, let 'em have marriage. I don't want them – why should I beg? Equality shouldn't be up for discussion.

JAMIE: Some synagogues do blessings- and some churches...

KELI: But they're not legal.

LEE: But that's not fair!

DARCY: My parents haven't spoken to me in two years.

Won't take my calls, won't answer my emails – they blank me in the street. I'm dead to them. They're dead to me. If that's what marriage and family is – You can keep it.

C.U. LEE – thinking...

INT. STREET OUTSIDE YOUTH CENTRE – NIGHT

People are kissing and hugging each other goodbye... LEE watches KARMEL watching KIM...

LEE: So, do you reckon you and Kim'll ever get that civil partnership thing?

KARMEL: We've only known each other three weeks! Are you mental?

LEE: But she is your girlfriend, yeah?

KARMEL: Lee!

LEE: What? Oh my days! You are so blushing! She is so totally your girlfriend! Cool...

They watch KIM together...

LEE: ...She's cute!

INT. OUTSIDE LEE'S HOUSE – NIGHT

MARIOS & ARISTOS are playing basketball – they stop and watch as JAMIE'S car pulls up and LEE gets out and kisses JAMIE goodbye. As LEE turns towards them, they quickly start to play again.

LEE: What?

LEE grabs the ball and dribbles…

LEE: Hey you know what gay people call marriage, like?

ARISTOS: Marriage, innit? That geezer from Torchwood's married to a bloke !

LEE: That's civil partnership! Don't you know nothing?

ARISTOS: What do care, anyway? Are you gay?

LEE: What if I was?

LEE and MARIOS exchange a look.

MARIOS: Lee… What's going on?

ARISTOS: Who was that bloke?

LEE: A friend?

MARIOS: Lee. What's going on?

LEE: I'm standing here asking you if you would care if I was gay – that's what's going on.

MARIOS: Of course we'd care. We care about you. We care about what people would say.

LEE: That's what you'd care about? What people would say about me?

MARIOS: And what they'd do. You know what they're like round here.

LEE: And what would you say about me?

ARISTOS: What we always say – wear a skirt you big lezzer.

MARIOS: But if anyone else says anything, they're dead, you get me? You're our sister, innit?

ARISTOS: Even if you are a dyke. Ey, you ain't though, are you?

LEE smiles and scores.

KARMEL'S STORY

INT. KARMEL'S BEDROOM – NIGHT

JUMPCUT THRU KARMEL – in a room plastered with boy posters – trying to decide between jeans and a skirt – she plumps for the skirt and leaves her room...

EXT. KARMEL'S HALLWAY – NIGHT

KARMEL hurrying down the stairs...

KARMEL: Going out!!!

KARMEL'S DAD *(O.S.)*: I know that voice! Is that our lodger?

KARMEL sighs...

KARMEL'S MUM *(O.S.)*: It can't be our daughter – sneaking out of house like a burglar!

KARMEL'S DAD appears in the kitchen doorway, KARMEL'S MUM in the living room doorway.

KARMEL'S MUM: Oh my God, it is our daughter...! It is her, isn't it?

KARMEL'S DAD: I don't know – it's been so long! Do you have any I.D., Missy?

KARMEL: I'm going out.

KARMEL'S DAD: With all that make-up? To where? Your pole-dancing job?

KARMEL: Mum!

KARMEL'S DAD: Who with - your boyfriend?

KARMEL: Mum!

KARMEL'S DAD: Pimp?

KARMEL: Mum!

KARMEL'S MUM: We just want to know where you're going and who with. We're your family – Why can't you talk to us?

CUT TO

INT. KARMEL'S LIVING ROOM – NIGHT (FLASHBACK.)

JUMPCUT THRU KARMEL'S MUM & DAD watching T.V.

KARMEL'S MUM: Oh god, another bender agenda!

KARMEL'S DAD: Why are we watching this homo propaganda crap?

KARMEL'S MUM: Why does there have to be a lesbian on every show?

KARMEL'S DAD: This is too gay for me...

KARMEL'S DAD/KARMEL'S MUM: Turn over!

CUT TO

INT. KARMEL'S HALLWAY – NIGHT

KARMEL looking at her MUM and DAD. CAR HORN OUTSIDE.

KARMEL: There's no boyfriend. I'm late.

KARMEL leaves...

INT. YOUTH CENTRE (GAY YOUTH GROUP MEETING.) – NIGHT

KARMEL: I hate my parents. I know everyone says that – but I really hate mine. Why shouldn't I? They hate me. And what's really pathetic is they don't even know they hate

me. No one knows they hate me – I'm the popular girl. The pretty girl – The girly girl – the straight girl. No one knows that every time they say 'That's so gay', about a crap song or a rancid meal or an unfair situation – they're talking about me. I tell myself I can take a joke. I say it too – and I hate myself for it. I hate that I'm so scared. I hate that I want to cry right now. I hate my life... It's just so... gay.

EXT. STREET OUTSIDE YOUTH CENTRE — NIGHT

People are chatting and... KARMEL is quiet again... She watches as a STRAIGHT couple stand at nearby bus stop, in a canoodling DANCE of love...

KARMEL reaches down and takes KIM'S hand. KIM – who is chatting with DANI – gives KARMEL a smile... DARCY approaches her, excited...

DARCY: Oh my God, Karmel!

LEE: Darcy's transferring to our college next Monday.

DARCY: I'm living with my nan now and it's nearer...

LEE: I told her, she's totally got to do drama with us!

KARMEL: Can you do that? Transfer in the middle of a year?

LEE: How brilliant is that?

> *At that moment, as the STRAIGHT COUPLE passes, JONAS lets out a wolf-whistle to giggles from the group. The STRAIGHT BLOKE turns on them.*

STRAIGHT BLOKE: You whistling at my bird, mate?

JONAS: No, mate ...I'm whistling at you.

> *STRAIGHT BLOKE is totally thrown – opens his mouth, then turns away, blushing... as he grabs the STRAIGHT GIRL to leave, she throws JONAS a wink.*

STRAIGHT GIRL: Good taste!

The GROUP watches them go – then burst into laughter and chatter...

KARMEL starts to relaxes a bit, then...

TEGS: Lee!

KARMEL and LEE look round to see TEGS and JORDAN across the road.

LEE: Teggsy!!!

KARMEL lets go of KIM'S hand.

TEGS hurries over to them, smiling. JORDAN stays put.

LEE: Y'alright?

TEGS: Yeah, we've just been see that new dance film.

LEE: We're going to that tomorrow, innit, Karmel?

TEGS: Oh, my days – it is proper amazing. We should get Mr Dawes to take the whole class!

LEE: Brainwave! We'll start on him first thing in the morning.

JONAS: Hey, Greedy Lee – didn't your mum teach its good manners to share? Who's your cute friend?

TEGS blinks in surprise. KARMEL is mortified...

LEE: This is Tegs – He goes to our college!

DARCY: Brilliant! I'm starting there on Monday!

TEGS: Wicked! You doing drama?

DARCY: I'm thinking about it!

JONAS: *(Smiling at TEGS.)* I'm thinking of enrolling myself.

TEGS: More the merrier!

TEGS looks round at JORDAN – who hasn't crossed the road.

TEGS: We gotta jump... Laters, yeah?

LEE: Peace!

TEGS hurries off to JORDAN, who nods goodbye, before leading the way off…

JONAS: How come the cute ones have always got boyfriends?

LEE: You what? They're not boyfriends.

JONAS: You are kidding me, right? I thought that other one was gonna jump across the road and tear my head off!

LEE: Jordan? *(Laughs.)* Jordan's not gay! Teggsy might be – everyone always says he is. Oh my gosh, that's hilarious! Did you hear that, Karmel?

KARMEL: Yeah. Hilarious.

INT. KARMEL'S HALLWAY/LIVING ROOM – NIGHT

KARMEL lets herself in. She can hear the TV. She looks in to the living room. KARMEL'S MUM and DAD are asleep on the sofa. KARMEL'S PHONE rings – KARMEL moves away from the door and hurriedly answers it with a whisper.

KARMEL: Yeah?

INT. LEE'S BEDROOM – NIGHT – INTERCUT

LEE: You alright?

KARMEL'S DAD *(O.S.)*: Karmel?

KARMEL: *(To LEE.)* I'm fine…

(To DAD.) I'm on the phone!

KARMEL'S DAD: Who to? The lesbian?

KARMEL: *(To LEE.)* I'll call you back.

KARMEL hangs up – calls out.

KARMEL: I'm just going to bed!

KARMEL'S DAD: Oy! I'm not your doorman, sweetheart! Come here!

KARMEL goes into the living room.

KARMEL: Yeah?

KARMEL'S DAD: Excuse me Missy – did you just 'Yeah' me?

KARMEL'S MUM: *(Sleepily.)* Hello, darling... have you eaten?

KARMEL'S DAD: Yeah me again, I dare you!

KARMEL: Why do you say things like that , Dad? Lee's my friend.

KARMEL'S DAD: Yeah. Your lesbian friend.

KARMEL: She's not a lesbian!

KARMEL'S DAD: Wake up, child – Have you looked at her?

KARMEL: Oh my God – you are so 20th Century!

KARMEL'S DAD: Some truths are timeless, Princess. If it looks like a lesbian, it acts like a lesbian – trust me – it's a lesbian. I let you be friends with her, don't I?

KARMEL: Oh, thanks.

KARMEL'S DAD: I let her into my home – stomping about in her Doc Martins.

KARMEL: She doesn't wear Doc Martins, Dad!

KARMEL'S DAD: She can wear what she likes it's a free country – As long as she doesn't make a move on my little Princess, this is Lesbian Tolerance Zone.

KARMEL turns to go.

KARMEL'S DAD: Oy! Where's Daddy's kiss?

KARMEL gives him a quick kiss and leaves.

Now I know there's recession on – Used to get hugs once... Now it's like she kisses me for a dare!

INT. KARMEL'S BEDROOM/LEE'S BEDROOM — INTERCUT

LEE and KARMEL on the phone...

KARMEL: God, I hate that word. It just sounds so... sleazy! 'Lezzzbian.' What's wrong with gay?

LEE: I like the word lesbian.

KARMEL: That's because you're straight!

LEE: No it's because my best friend's a lesbian, innit?

KARMEL: Stop calling me that!

LEE: You are though! ...Maybe you should just tell your parents.

KARMEL: Are you entirely mental? Anyway, I probably won't have to. It'll be round the whole of sixth form college by lunchtime!

LEE: What, that we was hanging out with a bunch of mates?

KARMEL: I was holding hands with a lesbian, Lee!

LEE: So was she!

KARMEL: Lee!

LEE: She's your girlfriend!

KARMEL: She's not my girlfriend!

LEE: You're a lesbian, Karmel!

KARMEL: Lee!

KARMEL hangs up. Covers her face and tries to breathe... Her PHONE starts to RING. KARMEL doesn't answer it.

EXT. BUS STOP — DAY

KARMEL gets off the bus to find LEE waiting at the bus stop – she walks straight past her.

51

LEE: I'm sorry, Karmel.

KARMEL: No you're not. You don't get it. You think I'm a coward.

LEE: I think you're brilliant exactly as you are.
Look, I don't care what people say or think.
People call me gay all the time.

NINA: Oy, Lesbian Lee!

NINA'S FRIEND: Too butters to get a man, innit?

NINA/FRIEND: Dykey, Dykey, we no likeee!

LEE: *(One finger salute.)* See?

KARMEL: But you're not, are you? At the end of the day, you're gonna get married – you're gonna be normal, you're gonna be accepted.

LEE: Well if it means losing you I don't want to be accepted. I'm your sister for life, Karmel. And whatever you choose to do, I've got your back. Okay?

KARMEL: Okay. So you gonna help me find a boyfriend?

LEE: A what?

INT. DANCE & DRAMA STUDIO — DAY

The CLASS is on a break – drinking water and towelling off sweat. LEE and KARMEL are checking out boys...

POV KARMEL/LEE: RYAN flicking water at someone...

KARMEL/LEE *(OFFSCREEN)*: No...

POV KARMEL/LEE: ISAAC flicking someone with a towel...

KARMEL/LEE *(O.S)*: Definitely no!

POV KARMEL/LEE: The person getting flicked is TEGS.

KARMEL/LEE *(O.S).*: Awwwwww!

LEE *(O.S.)*: I don't think he'd be interested, babe…

KARMEL *(O.S.)*: Shame though…

POV KARMEL/LEE: JORDAN grabs ISAAC'S towel off him and chucks it him.

KARMEL *(O.S.)*: Fit – but too moody.

LEE *(O.S.)*: And gay.

KARMEL *(O.S)*: Not everyone is gay, Lee!

POV lands on TYLER.

KARMEL *(O.S.)*: …hmmm – Tyler…?

LEE *(O.S.)*: Good dancer.

KARMEL *(O.S.)*: Nice skin…

TYLER glances over – realises he's getting checked out and smiles shyly…

LEE *(O.S.)*: And interested! 10, 10, 10! Full marks! Now what? …Karmel?

KARMEL is already marching over to TYLER.

KARMEL: Hi Tyler.

NINA: Alright?

KARMEL: Wanna go on date?

NINA: Uh, yeah!

KARMEL: Sweet! Call me!

KARMEL goes back to LEE.

KARMEL: Sorted.

LEE gapes…

LORIS: 2-3-4!

…and they are swept up into the dance routine.

INT. STREET OUTSIDE YOUTH CENTRE — NIGHT.

The YOUTH GROUP MEMBERS are chatting. KARMEL has cornered CHARLOTTE.

KARMEL: Okay, so – you're bisexual, yeah?

CHARLOTTE: Is that a problem?

KARMEL: No!

CHARLOTTE: Has someone got a problem with me in the group?

KARMEL: Charlotte...

CHARLOTTE: I'm not some cop-out plastic part-time lesbian, I just think labels are for clothes and cans of...

KARMEL: Charlotte! I'm not judging you! I just wanted to ask – what it's like – with... boys…?

CHARLOTTE: Oh.

(Looking at KARMEL.)

...Oh! Well – they're – I don't know... Boys are boys. People are people. I mean they're bigger – sometimes – their hands are bigger – they're hairier – their bodies are harder – their lips are definitely harder – and there's the smell...

KARMEL: ...smell?

CHARLOTTE: And the stubble – that takes some getting used to – But otherwise they're basically the same. …er, why do you ask?

KARMEL: ...Why? Well... nothing, it's just... I'm going on a date with a boy... and I was wondering what to expect.

CHARLOTTE: What about your girlfriend?

KARMEL: Who, Kim? Kim's cool, but you know, we're young – I'm only seventeen and we're not actually officially girlfriends yet.

CHARLOTTE: Does Kim know that?

KARMEL looks over at laughing chatting oblivious KIM.

INT. BFI RIVERSIDE RESTAURANT — NIGHT

KARMEL and TYLER read menus. Awkward silence.

NINA: Decided yet?

KARMEL: Ummmmm....

NINA: There's legs or breast – er, chicken breast – or Chicken wings. I think I'll go for chicken wings – cool...

(Closes menu.)

...Cool. How about you? We could get chicken wings for two...

KARMEL: I'm a vegetarian?

NINA: You're…? Oh, man! I didn't... why didn't I know that? I should have asked though, innit? I'm a a total muppet! So gay!

KARMEL: It's fine. There's loads of veggie options. I love it here.

NINA: You're a proper nice, innit?

KARMEL: You sound surprised.

NINA: Well, girls who look like you – they can be a bit... you know... I don't know. And we've never had a conversation. You're always with your mate – the one that looks like a... that dresses like a boy.

KARMEL: Lee.

NINA: Lee. Yeah. She's a wicked dancer, though. ...So are you.

KARMEL: Thanks.

NINA: *(Blurts out.)*

You're fit. Sorry. But you are.

KARMEL: Thanks.

KARMEL realises that TYLER is waiting...

KARMEL: So are you.

NINA: Yeah?

TYLER beams – reaches across the table to take KARMEL'S hand.

NINA: Ta. I've been working really hard on my abs and that...

At that moment outside the window behind TYLER, KARMEL sees KIM walking along, chatting with DARCY and CHARLOTTE...

NINA: ...I've even joined a gym... Three times a week. Well, two sometimes...

KIM is looking at KARMEL – holding hands with TYLER.

NINA: I'm gonna be a footballer – well I wanna be dancer – but that's a bit gay innit – so I'm gonna be a footballer.... you okay?

KIM smiles sadly at KARMEL – then walks away.

KARMEL lets go of TYLER'S hand.

EXT. OUTSIDE KARMEL'S HOUSE – NIGHT

KARMEL and TYLER in a awkward silence.

NINA: Okay... well... that was wicked. You're amazing. In a sort of cool... mysterious way...

TYLER goes to kiss KARMEL – she jumps out of her skin.

NINA: Sorry! Did I... sorry. I only meant to... *(Touches KARMEL.)* ...Say goodnight...

TYLER kisses KARMEL – she is frozen. He tries to put his arms round her, her eyes widen in panic... Then...

KARMEL: *(Suddenly struggling…)* Get OFF me!

NINA: Sorry! I just wanted to…

The front door opens and KARMEL falls into KARMEL'S DAD'S arms...

KARMEL'S DAD: What's going on?

NINA: Oh God! I'm not… I was just...

TYLER runs for it...

INT. KARMEL'S LIVING ROOM – NIGHT

KARMEL sits silently staring into space.

KARMEL'S MUM: Karmel babe... talk to me, love... Are you sure that boy didn't do anything to you?

KARMEL: He was lovely to me...

KARMEL'S MUM: Did your Dad do something?

KARMEL shakes her head.

KARMEL'S MUM: Is it your time of the month?

KARMEL: No!

KARMEL'S PARENTS look at each other.

KARMEL'S MUM: Are you pregnant?

KARMEL'S smiles bitterly – shakes her head. KARMEL'S PARENTS sigh in relief...

KARMEL: I'll never be pregnant. ...I'm going to bed.

KARMEL'S parents watch her leave... They sigh....

KARMEL'S DAD: Drama queen.

KARMEL'S MUM: She's just cheesed off because you interrupted them...

KARMEL'S DAD: ...Thank God.

INT. KARMEL'S HALLWAY – NIGHT

KARMEL listening...

KARMEL'S MUM (O.S.): For moment there, I thought it was something serious.

KARMEL'S DAD (O.S.): At least she didn't come out with 'I'm gay' or something like that.

KARMEL'S MUM: That's all we need...

INT. KARMEL'S BEDROOM/KIM'S BEDROOM — NIGHT

KARMEL lying on her bed sends a text.

KIM, lying in her bed, reads it. 'Forgive Me'

KIM answers the phone…

KARMEL holds her phone and waits, surrounded by posters of boys...

TEGS'S STORY

EXT. PLAYGROUND – DAY

TEGS, hoodie up – Walking quickly. In his head he hears...

SOUND FX laughter – BOYS & GIRLS mocking him.

ISAAC (V.O.): Oy! Gay boy!

RYAN (V.O.): Oy! Poofter!

>*TEGS sees a football lying near a drain. He stops. He looks around. He lines the ball up with the goal white-washed on a school wall... he kicks. He misses.*

ISAAC/RYAN (V.O.): Queer! Battyman!

>*TEGS stumbles…*

INT. COLLEGE HALLWAY – DAY

TEGS hurrying through the hallway – pushing through the doors to the DANCE & DRAMA STUDIO.

INT. DANCE & DRAMA STUDIO – DAY

SOUND FX Mocking laughter – taunting voices.

JUMPCUT THRU: TEGS pulling off his hoodie and his trainers – pulling on his tap trainers.

TEGS taps.

The laughter stops – Then starts again.

TEGS taps – harder this time – the laughter stops.

JUMPCUT THRU TEGS snapping on the stereo plugging his ipod – pressing play –

MUSIC – HIP-HOP BEATS.

TEGS starts to tap. Closing his eyes – getting lost in the music – getting swept up in the rhythm of his feet – dancing, dancing, dancing and the laughter has gone.

Suddenly the MUSIC STOPS.

TEGS whirls round at ISAAC and RYAN – who is holding TEG'S ipod.

RYAN: Who's a sweaty girl, then? *(Flicking through the ipod.)* Nice equipment, Teggsy baby....

ISAAC: *(Grabbing the ipod.)* G'iss a look!

The ipod hits the ground.

RYAN: Oh man! Careful of Teggsy's hardware, man! It's delicate...

TEGS hesitates, then goes towards his ipod... RYAN kicks it – it slithers across the ground... TEGSSY goes after it. But ISAAC is there before him, kicking it again, as RYAN and ISAAC go into a football match –

RYAN: He shoots – he scores!

The ipod slithers to stop at a new pair of pristine white trainers standing in the doorway. We PAN UP to JORDAN'S stony face. RYAN and ISAAC stop in their tracks.

JORDAN: *(To TEGS.)* You alright?

TEGS: I'm cool.

TEGS moves forward to pick up the ipod.

JORDAN: Did you drop it?

TEGS stops – glances at ISAAC and RYAN, who have still not moved.

JORDAN: Whoever dropped it – should pick it up.

TEGS picks up the ipod.

At that moment, LEE and KARMEL burst in laughing.

LEE/KARMEL: Alright, Teggsy?

TEGS: Alright?

LEE and KARMEL look around at the standoff.

LEE: What's wrong?

RYAN: You mean besides that hat?

LEE/KARMEL: Die, Ryan!

KARMEL: ...Have they been starting on you, again, Teggsy?

(To JORDAN.)

Have they been starting on him?

TEGS: I'm cool!

RYAN: *(Arm round TEGGSY'S shoulder/neck.)* See, Teggsy's cool.

ISAAC: *(Leaning on TEGS.)* We just been bonding, like – Innit – T-man?

TEGS: Yeah, man...

ISAAC: Wha' you saying? Teggs ain't man enough to fight his own battles?

RYAN: You're man enough to fight your own battles ain't you, Teggsy princess?

JORDAN: Let go of him.

RYAN: Wassamatter Jordan, man? Jealous?

ISAAC: Want a little Teggsy all to yourself?

JORDAN steps forward.

TEGS: Jordan...

JORDAN: Leave him.

At that moment The REST OF THE CLASS come rushing in, pushing through the deadlock.

EXT. PLAYGROUND – DAY

TEGS kicks the ball at JORDAN in goal... it goes nowhere near it.

TEGS: I am rubbish.

JORDAN: You are not rubbish, man – You're just...

TEGS: ...crap?

JORDAN: ...Getting the hang of it... *(Fetching the ball.)* You should have let me sort them wastemen out.

TEGS: And get excluded again?

JORDAN juggles the football, face set...

TEGS: Isn't that why you got from excluded from your last sixth form college? Fighting?

JORDAN: Wouldn't be no fight, man... *(Holding up a fist.)* One punch, blood – end of – you get me?

TEGS: I like it when you talk gangsta.

They smile...

JORDAN: Wanna try basketball? *(TEGS groans.)* Don't give up before you start, man.

TEGS: I don't think balls are my thing.

JORDAN laughs. TEGS blushes.

JORDAN: Remember what sir said – everything's just a dance... You're good at dancing, yeah?

TEGS shrugs.

JORDAN: Well, that's all it is, man...

JORDAN dances with the ball, hip-hop style...

JORDAN: ...Rhythm, movement, your body...

JORDAN does a little piss-take ballet dance – TEGS laughs. JORDAN bounces the ball at him

JORDAN: ...and a ball!

– TEGS manages to catch it...

JORDAN: See? Just imagine there's music, yeah?

TEGS bounces the ball back to JORDAN.

JORDAN: Nice.

JORDAN bounces it back to TEGS. TEGS catches it.

JORDAN: Nice. Now, move a bit, yeah?

TEGS and JORDAN start to circle it each other, bouncing the ball back and forward.

JORDAN: Own the area, yeah? It's all yours, it's all you... all part of you – the ground, the air, the ball...

JORDAN juggles the ball – doing tricks – TEGS notices that some GIRLS are watching.

TEGS: You got a fan club.

JORDAN: *(Stops juggling.)* We're late...

INT. DANCE & DRAMA STUDIO — DAY

TEGS and JORDAN warming up...

TEGS: How does it feel being a babe magnet, then?

JORDAN: You tell me... you're the one who's always surrounded by girls.

TEGS: What, Lee and Karmel? They just feel sorry for me.

TEGS looks across the room at RYAN and ISAAC chatting and laughing with a CUTE GIRL.

TEGS: Girls like sporty lads...

JORDAN: ...Do they?

Across the room, they notice TYLER glancing over at KARMEL, who is totally blanking him…

TEGS: What do you think happened there? I mean – Tyler and Karmel – talk about a fit couple...

JORDAN: Not everyone likes the same kind of fit.

TEGS: Easy for you to say...

JORDAN: Not everyone likes who they're supposed to like.

Some thing catches TYLER'S EYE – DARCY arriving, looking around for someone...

TEGS: Hey, that's Darcy! Lee and Karmel's mate.

DARCY spots LEE and KARMEL and runs over to say hi... LEE is thrilled, KARMEL finds an instant excuse to get away.

TEGS: Harsh! Blatantly giving her air!

JORDAN: You know what girls are like – proper competitive.

MOLLY (17, petite, cute, white.) approaches...

MOLLY: Tegs...

TEGS: Oh! Hey Molly...

MOLLY: How does that move after the turn go again?

TEGS: The one with the arm...?

MOLLY: Yeah! Does it go up on the beat or down?

TEGS: It's down... *(Demonstrates.)* 2-3-down...

TEGS/MOLLY: 2-3-down...

MOLLY: You're amazing, thanks!

MOLLY moves off.

TEGS: See? I'm just Tegs the mate...

JORDAN: Man, you're not even pretending are you?
You really don't get it.

TEGS: Get what?

JORDAN: You don't see the way some people look at you.

TEGS looks round in surprise, MOLLY is talking excitedly with her mates.

They look over at TEGS...

TEGS: ...at me?

LORIS: Routine, people!

THE CLASS moves back into dance formation...

JORDAN: Face it man – you're cuter than you think you are.

TYLER positions himself next to DARCY – throws her a smile.

LORIS: Remember we are all dancers! One two three...

The CLASS goes into the dance routine – TEGS makes eyes contact with MOLLY. They exchange shy smiles – JORDAN takes this in... so does RYAN...

The routine ends...

MOLLY: Was that right?

TEGS: That was wicked.

MOLLY: Yeah? Thanks...

TEGS: Wicked...

TEGS moves away from MOLLY – mouthes at JORDAN – 'Oh... my... God!'

...takes a sip from his water bottle... then spits it out.

LORIS: *Mister* Tegs, you're not at home now! Clean that up!

TEGS grabs his towel, wipes his tongue and starts mopping up.

JORDAN: You okay?

TEGS: I'm cool.... Can I have some of your water, man?

JORDAN hands TEGS his water and snatches TEGS'S bottle and sniffs – he looks across at RYAN and ISAAC grinning at TEGS...

TEGS: Jordan...

JORDAN strides across the room and shoves ISAAC to the ground and empties the bottle over ISAAC'S FACE.

RYAN: Sir!

INT. OUTSIDE DANCE STUDIO

TEGS watches from a distance as LORIS faces, ISAAC, RYAN and JORDAN.

LORIS: Question: Do you want to stay in this class?

Various shrugs, small nods...

LORIS: Then don't make me kick you out. I don't like giving up on people – that's not my style. But if they give up on themselves – what's left? If anyone has any problems that they want to discuss with me, one to one, my door is open – I am willing to listen. And that's anyone, okay? Even you may have done the wrong thing, I'm ready to hear why and to try and understand and try and sort things out. Okay? Okay... Go...

THE BOYS get to their feet...

EXT. OUTSIDE LUNCH TABLES — DAY

RYAN blows TEGS a kiss from his table... JORDAN gets to his feet, TEGS gently stops him.

TEGS: Jordan...

JORDAN: He's lucky I didn't make him puke then eat it – chief!

TEGS: It's not like it's just him, though is it?

JORDAN: What?

TEGS: Come on Jordan, everyone round here thinks the same thing – the whole college does – My old college up north thought exactly the same thing.

JORDAN: What you chatting about, man?

TEGS: Everyone thinks I'm a freak.

JORDAN: I don't.

TEGS: I'm a proper freak. I can't even kick a ball.
Even girls can kick a ball. Proper freak.
Before you came here, it was worse.
That's why I didn't come in. Used to ride the bus to college every morning right to the end of the line – and just walk and bus around London. Proper freak.

JORDAN: You ain't a freak.

TEGS: And the worst thing is, you keep getting dragged into it just for being my mate and you're even less gay than I am. At least I'm an honorary gay. I'm practically an honorary straight - I've never even kissed anyone.

JORDAN: You can kiss someone now if you like.

TEGS stares at JORDAN.

JORDAN: Then we can both find out. No - I don't need to find out... I know. I love you Tegs.

TEGS: And I love you.

Pause.

JORDAN: But you don't want to kiss me.

TEGS: If I say no can we still be friends?

JORDAN: Either you do or you don't.

TEGS: ...I'm sorry, man.

JORDAN: *(Face hardening.)* No. I'm the one who's sorry.
(*Eats, then...*) So you just been hanging out so I can be your
guard dog, yeah?

JORDAN walks off.

TEGS: Jordan...!

MOLLY: Tegs!

TEGS turns to see MOLLY hurrying towards him.

MOLLY: You didn't get expelled then?

TEGS: No, you're stuck with us a bit longer.

MOLLY: And you're alright?

TEGS: Yeah.

MOLLY: You walking to the tube?

TEGS: I dunno – we were...

TEGS looks around and see that JORDAN is gone...

TEGS: Okay...

CUT TO

INT. STREET — DAY

MOLLY and TEGS walking. She chatters away. He is blank.

INT. TEG'S BEDROOM — NIGHT

TEGS on the phone.

JORDAN: Leave a message, yeah? ...Safe.

BEEEP!

TEGS: Jordan. I'm really sorry. Look, just give us a call when
you get this... thanks. Bye.

TEGS hangs up. Thinks. Throws down his phone and grabs his laptop...

INTERNET: Your! Mailbox! Is! Full!

TEGS is surprised... He opens an e-mail DIE FAGGOT! He opens another one. BURN IN HELL, BATTYMAN... then another... TOMORROW U DYE...

Email after email of hateful messages... TEGS slams his lap-top shut and closes his eyes, tries to control his breathing... suddenly there's a smash and something hits the curtain and bounces into the room. The window glass glitters on his carpet. TEGS runs to the window – looks out... nothing.

TEGS'S MUM: Terry!!!

TEGS: It's fine, mum!

TERRY'S MUM knocks on the door.

TEGS'S MUM: Terry...!

INT. TEG'S BEDROOM — FIVE MINUTES LATER (NIGHT.)

MUM watches TEGS empty a dustpan of glass into the bin...

TEGS'S MUM: Do we need to find another college?

TEGS: It's fine, mum...

TEGS'S MUM: I'm calling 'em up in the morning.

TEGS: It's nothing to do with college.

TEGS plucks a knife from off the draining board and slips it up into his sleeve...

TEGS: It's just kids playing footie in the street. Please just leave it.

TEGS'S MUM: Are you hungry?

TEGS: No.

TEGS'S MUM: I don't understand it. You're such a good boy, how can anybody not love you?

TEGS stops in the doorway – in his head he hears….

MONTAGE FLASHBACKS – RYAN with his arms around TEGS, blowing 'sarcastic' kisses across the school yard. Touching TEGS again and again…

TEGS'S MUM: I know I'm your mum, but… You sure you're not hungry?

TEGS: You know what…?

TEGS slips the knife back out of his sleeve.

TEGS: …I'm starving.

INT. DANCE & DRAMA STUDIO — DAY

TEGS smiles in the mirror…

INT. PLAYGROUND — DAY

RYAN is practising football – it rolls and lands at TEG'S tap shoes… We PAN UP to TEG'S face…

TEGS: Who's a fit boy, then? …Well fit.

RYAN: You what?

TEGS: It's okay, Ryan… I understand. You can't just come out say it… you don't have to.
Some things are beyond words… but if ever you want to… you know get together – swap some skills… you know where you can find me…

(Smiles knowingly.)

Cool?

RYAN looks around – they are alone in the empty playground.

RYAN: I...

(Looks down shyly at the ball in his hands.)

yeah... that'd be...

(Looks up.)

...cool.

But TEGS is gone. And RYAN is alone.

INT. HALLWAY — DAY

TEGS sees JORDAN up ahead.

TEGS: Jordan!

JORDAN stops and lets TEGS catch up.

TEGS: I'm sorry – I freaked out.

JORDAN: You ain't a freak.

TEGS: And you're not my guard dog.

JORDAN: Yeah I am.

TEGS: Did you miss me? Maybe?

JORDAN: I think someone missed you more...

TEGS looks round. MOLLY is waiting for him.

JORDAN: See you in class, yeah?

(Smiles.)

Don't be late...

JORDAN goes on ahead... TEGS and MOLLY approach each other, smiling.

JORDAN'S STORY

INT. JORDAN'S BEDROOM — NIGHT

ALARM CLOCK. JORDAN's hand snakes out and turns it off. He groans – twists over in bed – sits up – gets up.

60 INT. JORDAN'S KITCHEN — NIGHT 60

JORDAN, in his tracksuit, eating a banana – drinking juice.

EXT. STREET — NIGHT

JORDAN running down the centre of the empty street.

EXT. FOOTBALL FIELD — NIGHT

JORDAN running on the spot – legs and arms like pistons.

JORDAN sprinting the length of the pitch –

JORDAN performing dribbling drills – juggling the ball...

PULL OUT to show RYAN training on the other side of the pitch. Separate worlds.

INT. JORDAN'S BATHROOM — DAY

JORDAN turns the shower jets on cold.

INT. JORDAN'S KITCHEN — DAWN

JORDAN drinking water, while chucking fruit into a blender. JORDAN'S MUM is making breakfast, LINUS, JORDAN'S younger brother, is doing press-ups against the kitchen table.

JORDAN: Looking good, bruv!

LINUS: I'm gonna do a hundred like you!

JORDAN: Good skills, man!

JORDAN'S MUM: Linus! Sit!!

JORDAN'S BROTHER: Can I have a protein shake, please, mum?

JORDAN'S MUM: You'll have what I give you, Superman!

JORDAN'S DAD comes in, dressed for work.

JORDAN'S DAD: Good one?

JORDAN makes a face and shrugs – drinking his shake.

JORDAN'S DAD: I'll have to come with you one of these days. Give you something to aspire to…

JORDAN pulls on his backpack…

JORDAN'S MUM: You – Give me a call if you're missing dinner, please!

JORDAN starts to leave

JORDAN: Standard!

JORDAN'S MUM: Call me anyway! Pretend its Mother's day!

JORDAN *(O.S.)*: *(From the hallway…)* Every day's Mother's Day!

EXT. PLAYGROUND — DAY

JORDAN juggles his ball while he flicks through photos on his phone – all of TEGS – Still juggling, JORDAN presses speed-dial…

'TEGGSY' comes up on his phone screen with a picture of JORDAN and TEGGSY lying together on some grass… at that moment, TEGGSY appears in the entrance with MOLLY. JORDAN hangs up, carries on juggling…

TEGS: Morning, my good man!

MOLLY: Hey, Jordan.

JORDAN: Alright?

TEGS: Were you just calling us?

JORDAN shrugs.

TEGS: Well, we were about to call you.

MOLLY: We're going to see that dance film this afternoon after college.

TEGS: We were wondering if you fancied coming with?

JORDAN: I dunno – I'm... you know...

TEGS: Training…?

TEGS and MOLLY exchange a look…

JORDAN: Another day, yeah?

MOLLY: We were hoping you would join us for lunch.

JORDAN: Thanks. I'm training lunchtime.

TEGS: Molly's brother Toby's meeting us.

JORDAN: Sweet.

TEGS: He is. Kind of. ...Sweet.

JORDAN: How sad do you think I am?

TOBY: Molly!

> *They turn to see TOBY at the gate – panting and sweaty – and cute.*

MOLLY: Hey you! You're early!

TOBY: I know! Uncool! And sweaty – I just thought I'd run past and make sure I'd googled the right sixth form college... Hey Tegs!

TEGS: Alright, mate!

TOBY smiles shyly at JORDAN, who is trying not stare.

TEGS: Toby – This is Jordan!

TOBY: I thought so! You're lunch, yeah – er, We're having you for lunch -er, having lunch with you – yeah?

MOLLY: Jordan has to do his training.

MOLLY flashes TOBY a 'Let it go' face…

TOBY: Oh! Okay… well,

 (About to leave.)

 …speaking of training…

JORDAN: See you at the film though, yeah?

TOBY: Film?

MOLLY: The dance film… You said it looked cheesy.

TOBY: I love cheese. I'm practically a mouse. Text me and I'm there, yeah?

 (Kisses MOLLY.)

 Laters, Milly-Molly.

 TOBY runs off. MOLLY and TEGS turn to JORDAN with knowing smiles.

JORDAN: *(Embarrassed semi-smile.)* …What?

MUSIC SEQUENCE – THROUGHOUT THE NEXT FIVE SCENES

INT. DANCE & DRAMA STUDIO — DAY

JORDAN is dancing in the middle of the FULL CLASS with a big smile on his face.

INT. PRINCIPAL BAILEY'S OFFICE — DAY

PRINCIPAL BAILEY: Due to good reports on your drama course, that the English tutor is willing to take you back on her course.

JORDAN beams.

JORDAN: You won't be sorry, sir!

PRINCIPAL BAILEY: We can only hope. *(Smiles.)*

INT. OUTSIDE PRINCIPAL BAILEY'S OFFICE — DAY

TEGS, KARMEL and LEE are waiting for JORDAN as he emerges from the office stone-faced. Then beams. They leap into each other's arms, hugging and jumping.

EXT. FOOTBALL FIELD — DAY

JORDAN TRAINING – over the other side of the pitch, RYAN is training too – RYAN'S football bounces over to JORDAN'S AREA... RYAN comes over to fetch it, JORDAN picks it up and lobs it back to RYAN with a friendly almost-smile...

JORDAN: ...Peace, yeah?

RYAN'S reaction...

INT. JORDAN'S GARDEN— NIGHT

JORDAN teaches LINUS the dance routine from college - they play football togetther.

INT. JORDAN'S BEDROOM — NIGHT

JORDAN flexing in the mirror – trying on outfits and discarding them. Finally he is happy.

MUSIC SEQUENCE ends as we hear...

JORDAN'S MUM: Jordan!

JORDAN: I'm eating out, mum!

JORDAN'S MUM: Someone's here to see you!

INT. JORDAN'S KITCHEN — NIGHT

JORDAN, JORDAN'S DAD, JORDAN'S MUM, JONESY and LINUS sit round the table looking JONESY the football scout.

JORDAN'S MUM: You want to go and watch television, Linus?

LINUS: Are you mental?

JORDAN'S MUM/DAD: Linus!

JORDAN: It's cool... Linus, don't talk to mum like that.

LINUS: Sorry, Mum...

 (To JONESY.)

 Well, go on...

JONESY: Thank you. Now, Jordan, we've been following your progress, as you know, in county matches. We've seen your passion and dedication for the game, and so I'm here to officially invite you to try out for the youth squad.

JORDAN: The club youth squad?

JONESY: None other.

JORDAN'S DAD: What about his A-Levels?

JORDAN'S MUM: *(Drily.)* A level.

JORDAN: Levels. I'm back up to two...

 JORDAN'S MUM and DAD light up – surprised...

JONESY: Yeah, yeah, it's important to us that you continue your studies - so, we good?

JORDAN'S DAD: Jordan?

JORDAN: *(Typically low key.)* Wicked.

JORDAN'S DAD: Apparently it's wicked.

JONESY: Wicked it is.

JONESY and JORDAN shake on it.

JONESY: What you studying?

JORDAN: English and Performing Arts?

JONESY: Performing Arts – that's a bit bent ain't it?
You wanna be careful round them ballet boys, son...

(Winks.)

...might be catching.

JORDAN'S face. Stung.

INT. BEDROOM — NIGHT

JORDAN, pulling on his jacket, can hear his parents downstairs through the open door...

JORDAN'S DAD: The man's a complete caveman.

JORDAN'S MUM: Shh! The kids are gonna hear you!

JORDAN'S DAD: I can't believe I let him use that word in my house!

EXT. STREET — NIGHT

JORDAN walks along, head down, back to his guarded self.

EXT. OUTSIDE TUBE — NIGHT

JORDAN approaches a waiting TEGS, MOLLY and TOBY.

TEGS: Started to think you weren't coming...

JORDAN: Had runnings to deal with.

TEGS flashes his eyes at JORDAN – silently cueing him...

JORDAN: *(To TOBY.)* Sorry.

TOBY: *(Smiles.)* S' all good.

EXT. RIVERIDE BENCH — DAY

TOBY: So, you live with your adopted parents?

JORDAN: Parents. They're my parents.

TOBY: Okay.

JORDAN: Families come in all shapes and colours, you know.

TOBY: Specially mine. Yours sounds cool, though. So they won't call an exorcist if you bring me home?

JORDAN: Who says I'm bringing you home?

TOBY: What so you ain't marrying me then?
Laters!

JORDAN: Oy!

Laughing JORDAN grabs TOBY'S hand, then walk together and then JORDAN spots KARMEL coming the other way – chatting with KIM – and then KARMEL sees them coming and her face freezes – and finally JORDAN realises that KIM and KARMEL are holding hands.

Also with them are LEE and DARCY, who immediately get chatting with TEGS and MOLLY.

KARMEL and JORDAN keep holding on to their respective date's hands, but say nothing...

INT. JORDAN'S KITCHEN — NIGHT

JORDAN comes in to find JORDAN'S MUM & DAD, doing the washing up. He stands looking at them.

JORDAN'S MUM: Are you okay, lovely?

JORDAN'S DAD: What's wrong?

JORDAN: I'm gay.

JORDAN'S MUM & DAD look at each other. JORDAN is tearful.

JORDAN: ...I'm gay.

JORDAN'S MUM: Oh love... come here.

She hugs JORDAN.

JORDAN'S DAD: Are you sure?

JORDAN looks at him.

JORDAN'S DAD: Okay. That's my last stupid question.
...Well! What a day!

Holds out his arms... JORDAN doesn't hug him.

JORDAN'S DAD: ...Too gay? Okay.

INT. JORDAN'S HALLWAY STAIRS — NIGHT

JORDAN comes out of the kitchen and finds LINUS sitting on the stairs...

LINUS: Does this mean you're not gonna be a footballer?

JORDAN: Why should it?

LINUS: Are you gonna tell people?

JORDAN: I suppose.

LINUS: Then you ain't.

LINUS stands up, goes up stairs and into his room.

INT. JORDAN'S BEDROOM — NIGHT

JORDAN lies on his bed surrounded by football posters.

INT. JORDAN'S BEDROOM — DAY

JORDAN lies awake. JORDAN'S ALARM goes. He snaps it off. Does not get up.

INT. FOOTBALL FIELD — DAY

RYAN plays football. No JORDAN.

INT. STREET — DAY

JORDAN walking – locked away in himself. He comes to a halt… there on a wall he reads 'Kill All Queers'.

INT. DANCE & DRAMA STUDIO — DAY

LORIS is teaching a warm-up – ISAAC and CHARLIE are whispering and giggling. ISAAC raises his hand.

ISAAC: Mr Dawes Sir!

LORIS: You can call me Loris.

ISAAC: Sorry – Mr Loris sir –

LORIS: *(To class.)* Stop! Hold it!

 (To ISAAC.)

 Yes?

ISAAC: Guess who we saw last night on the South Bank, holding hands with their gay lover?

 LEE glances at KARMEL – she is frozen.

 TEGS and MOLLY's eyes dart towards JORDAN – no expression on his face.

LORIS: I have no idea, young Mr Isaac – who could it have been?

CHARLIE: So, is that your husband, Mr Loris, sir?
He's a bit young, ain't he?

LORIS: He moisturises. Any other questions or are we going
back to good old fashioned minding our own business?

CHARLIE: Is he your husband, though like? Are you married?

LORIS: I am married, we have a civil partnership.

ISAAC: So were you born gay? Or did you just turn when were
you abused, sir?

LORIS: Being gay and being abused are two totally separate
things, Mr Isaac. And you don't turn gay – you are or you
aren't.

ISAAC: That girl in Sex in the City, she turned gay and she was
married before.

LORIS: It's not about turning, Isaac. It's about knowing who
you are, being who you are and love who you love. How
many gay people do you know?

ISAAC: 'Sides Lee, you mean?

KARMEL: Shut up! She's not gay, you knob!

ISAAC: How do you know? You her boyfriend?

LORIS: Okay. Everybody sit down. Please. Thank you…

The class sits…

LORIS: Okay, how many gay people do you actually know?

CHARLIE: Not as many as you.

CHARLIE and ISAAC crack up.

LORIS: I answered your question…

CHARLIE: …None.

RYAN: Them people know better than to do their dutty
business round us, innit?

ISAAC: Nasty, man!

LORIS: And now the truth: You know gay people. They just can't tell you that they're gay.

ISAAC: Good! I don't want them to tell me.

LORIS: Well, then it's all going to plan, isn't it? Cause you are not the kind of friend who can be trusted with that information.

CHARLIE/ISAAC: 'Friend?'

RYAN: You trying to say we got gay friends?

CHARLIE, ISAAC and RYAN start shoving each other away.

ISAAC: I knew there was something about you, bruv!

LORIS: I'm saying there are gay people in this school – in your family who cannot tell you that they're gay because of how you'll respond.

RYAN: You're saying there's queers in my family?

LORIS: There are gays in every family – in every school – in every class.

CHARLIE: Yeah…

RYAN/CHARLIE/ISAAC: …Lee!

DARCY stands.

DARCY: Oh, for God's sake! Me! I'm gay alright!

Pause. LEE stands.

LEE: And me!

KARMEL: Lee…!

ISAAC: Obviously!

JORDAN stands.

JORDAN: …And me.

EVERYONE stares at JORDAN.

CHARLIE: Whassamatter, mate? Feeling left out?

ISAAC: Yeah, man – Mr Football training – you are so gay!

JORDAN: You always said I was Teggy's boyfriend...

ISAAC: 'Cause he's blatantly in love with you.

JORDAN: Well, he ain't. He's in love with someone else and I was gutted. It's me.

DARCY: ...And me.

LEE: And me.

ANOTHER stunned silence. TYLER'S face is a picture.

ISAAC: What the blood-fire is going on in this place, man?

CHARLIE: Its an epidemic!

ISAAC/CHARLIE: Raatidibungle!

MUSIC as the class continues. DARCY smiles at LEE and mouthes 'Thankyou.' LEE smiles back – she turns to KARMEL but KARMEL flashes her an angry look. JORDAN sits up straight, thinking, processing what he's done – he smiles to himself.

EXT. SCHOOL PLAYGROUND — DAY

JORDAN bops out for his lunch along with DARCY, TEGS, MOLLY, LEE & KARMEL. TOBY is waiting for them. JORDAN smiles a mile wide and heads straight for him – takes TOBY'S hand as they leave together...

ISAAC, CHARLIE and RYAN, watch – laughing, shaking their heads – RYAN can't take his eyes off them.

ISAAC: I swear, blood, it's like a gay bar up in this school these days.

CHARLIE: It shouldn't be legal, man.

ISAAC: It ain't legal is it? To be gay in school?

CHARLIE: I'm gonna google it, man... you got credit on your phone?

POV RYAN: TEGS and MOLLY holding hands.

RYAN: I tell you what's really sick, breh – that little pansy holding hands with Molly, like he's fooling people.

ISAAC: Innit, though? If you're gonna be gay, be gay, yeah?

CHARLIE: At least have the guts to be proud about it.

RYAN: You know what I mean? Double sick, man. Double sick...

RYAN'S STORY

INT. DANCE & DRAMA STUDIO/HALLWAY — DAY

RYAN watches through the door-glass as TEGS and MOLLY dance together, working on a routine. He darts away as they head for the door, watches from round the corner as TEGS and MOLLY go off down the hallway – chattering away…

RYAN slips into the STUDIO, closes the door. He goes over to TEGS'S bag.

He finds TEGS'S phone – scrolls through the pictures… there are pictures of

TEGS and MOLLY, smiling, laughing, kissing… There's a picture of JORDAN… there's pictures of JORDAN and TEGS together – pictures of JORDAN and TOBY – pictures of TEGS alone. Pictures that TEGS has taken of himself in the mirror – trying to look muscular…

RYAN pulls out his phone and starts blue-toothing TEGS'S pictures across. BANG! The door – RYAN is startled to find ISAAC and CHARLIE bowling towards him…

CHARLIE: What you got there, man?

> *RYAN scrolls frantically back through TEG'S photos while swiftly hiding his own phone*

RYAN: Tegs's phone, man! Bare gay pics!

ISAAC: No way, dread!!!

RYAN: Just blatant porn, blood! Check it, yeah?

> *He holds out a cosy picture of TEGS and JORDAN lying on grass together.*

ISAAC/CHARLIE: Urrrrr!!

ISAAC: Aaaaaabsolute sodomite, blood!

CHARLIE: *(Going through the pictures.)* My eyes, myeyes! They bleed!

ISAAC: *('Shooting' phone.)* Brap! Brap! Slew them! Burn Chi-chi man!!

ISAAC: Is this his stuff?

They look at TEG'S BAG.

JUMPCUT THRU ISAAC, CHARLIE and RYAN kicking TEG'S bag round the room. Pulling his stuff out, squirting cocoa butter all over it's contents.

CUT TO ISAAC, CHARLIE and RYAN, laughing as they spill out into the hallway...

They split up. The door slams behind them.

Silence.

Door opens and RYAN hurries back in.

JUMPCUT THRU: RYAN attempting to gather up TEG'S stuff. His fingers get covered in gunk. It's a lost cause...

The door opens. TEGS comes in He stares at RYAN.

RYAN: Just got out of hand. You can take a joke, yeah?

RYAN heads for the door.

RYAN: Tell anyone, you're dead.

RYAN stops at the door.

RYAN: Get me?

TEGS goes over to his stuff. RYAN goes back to TEGS and punches him in back of the head. RYAN runs out of the room.

EXT. PLAYGROUND — DAY

RYAN runs out of the building and out of the gate.

EXT. STREET — DAY

RYAN running.

EXT. FOOTBALL FIELD — DAY

RYAN paces, catches his breath – caged in an open field.

Suddenly exhausted, He slumps to the ground into a sitting position, is there a moment, then keels gently over onto his side then curls up like a baby and closes his eyes.

Everything is black and silent except for the sound of RYAN'S breathing...

then there is a panting sound...

And RYAN opens his eyes to come face to face with a dog.

LUCA: Dita! Leave!

DITA THE DOG does not move.

LUCA: Insolent Bitch! Sorry... She just wants to be sure you're okay. ...is this a performance art thing - or are you just on crack? Can I help you up or will you stab me with a dirty needle?

RYAN gets up unaided.

RYAN: I've seen you before. You're Mr Drama Teacher's boyfriend.

LUCA: Husband.

(Offers RYAN water.)

Seriously, are you okay? Did you have some kind of fit?

RYAN: I don't know.

LUCA: I suppose that answers that.

RYAN: I don't know how I got here. I don't know who I am.

LUCA: Wow. Really? Amnesia? I'm jealous.

(Pulling out his phone.)

Hmm... Do you call an ambulance for Amnesia?

RYAN: I remember everything. I just don't know how it happened. There's a boy – at school – at college – he makes me do things – say things – things I don't want to say.

LUCA: Have you reported him to anyone?

RYAN shakes his head.

LUCA: Well, maybe you should. Look what it's doing to you.

RYAN: It's not his fault.

LUCA: *(Sighs.)* Oh dear...

RYAN: It's me. I bring it all on myself, I can't stop myself. I think... I might be...

RYAN hides his face in his hands...

LUCA: Whatever you are it doesn't give anyone the right to make you do anything you don't want to, okay? No one has any excuse to hurt anyone else.

RYAN: What if you love them, though?

LUCA: It isn't love if it hurts.

RYAN: I read somewhere that love is a sort of madness – similar hormones or something.

LUCA: Similar is not the same. If it hurts it's not love. Just hurt. Have you tried talking to this person about how they're making you feel?

RYAN: I don't know how. I've not talked to no one about none of this before.

LUCA: Well, then, the only way is up. So, what are you doing tonight?

RYAN looks at LUCA.

LUCA: Don't worry, I'm straight. Okay, obviously I'm not straight – I just don't fancy you – and I'm married. Can your ego handle that?

RYAN smiles, in spite of himself, and nods.

LUCA: I've got some friends your age I'd like you to meet. It's a social group where you can talk about things and no one will judge you. Meet you on Southwark St at six and we'll see if we can sort things out things for you. Deal?

Pause.

RYAN: Deal.

EXT. STREET/PLAYGROUND — DAY

RYAN walking, answering his ringing phone.

RYAN: Yeah.

CHARLIE: Oh, thanks for answering, geezer! Know what I mean?

ISAAC: Gimme that!

(Snatches phone.)

Where you been, fool? Making us rinse out our credit leaving messages...

CHARLIE: *(Snatching back phone.)* Mr Dawes is well on the war path with you bruv.

RYAN: 'Cos of the bag an' that?

CHARLIE: What bag? 'Cos you missed a lesson, you pillock!

ISAAC: Gimme that!

(Snatching phone.)

Bag weren't a problem.

Teggsy never mentioned it. Proper bottled it. You coming over mine? Play PSP?

RYAN: Nah, I'm home, now man, I got business I gotta run...

ISAAC: What business?

RYAN: Business that minds its own! Laters yeah?

RYAN hangs up and unlocks his door.

INT. RYAN'S HALLWAY — DAY

RYAN strides in and heads for the stairs...

RYAN'S SISTER (O.S.): *(From the kitchen.)* Ryan!

RYAN: I'm going toilet!

RYAN'S SISTER throws open the kitchen door.

RYAN'S SISTER: RYAN!

RYAN: What? Why you gotta start bellows the second I reach home?

RYAN'S SISTER: There's someone here to see you.

INT. RYAN'S KITCHEN — DAY

RYAN, RYAN'S SISTER and RYAN'S DAD and JONESY it round the kitchen table...

JONESY: ...and so I'm here...

 RYAN translates for his DAD.

JONESY: ...to officially invite you to try out for the youth squad.

 RYAN translates.

RYAN'S DAD: *(Chinese.)* I understand....

RYAN: *(Translating.)* "I understand".

RYAN'S DAD pats his son on the shoulder. RYAN is stunned and then his smile is a mile wide.

RYAN: I don't know what to say.

JONESY: *(Jokey.)* Just don't say, 'I'm gay', mate.

RYAN'S face drops.

JONESY: That's all I ask...

RYAN'S DAD: *(In Mandarin.)* What's he say?

RYAN translates... RYAN'S DAD laughs – he clinks beer cans with JONESY...

JONESY: Another lad I spoke to – couple of days ago – called me back and said he was gay and did I have a problem. Course I said no – cause I don't!

RYAN: Really?

JONESY: But he's got a hell of a problem, if you ask me!

RYAN'S DAD fetches his camera, starts taking pictures...

JONESY: Don't get me wrong, I like Elton John as much as the next bloke...

RYAN'S DAD: See? You can do something right.

JONESY: ...but lets face it – How many premier league pansies do you know? Eh?

JONESY and RYAN'S DAD laugh together... RYAN sits silently. RYAN'S SISTER watches his face.

INT. RYAN'S BEDROOM — DAY

RYAN lies on his bed, surrounded by football posters and pictures of girls.

He looks at his watch. Jumps up.

EXT. STREET OUTSIDE YOUTH CENTRE — NIGHT

LUCA, RYAN and DITA walking together.

RYAN: Apparently my first word was 'football'... made my Dad so happy. Soon as I could walk, I wanted to kick a ball.

LUCA: Coincidence! Soon as I could talk I wanted to kiss a boy.

RYAN laughs as they enter the building.

INT. YOUTH CENTRE (GAY YOUTH GROUP MEETING.) — NIGHT

JORDAN has joined the GAY GROUP.

JORDAN: First year of Secondary school – One look – I knew. He was dead skinny, but lovely. And they used to knock the crap out of him. And I used to let 'em. I used to watch. Til one day, he tried to hang hisself with his shirt in the changing rooms while the rest of us was playing football. Ambulance came. Took him away. And people started laughing about it. Someone took Melvin's bag – started kicking it around. And I never said nothing. But I knew. I loved him.

The door opens and EVERYONE looks round as LUCA and laughing RYAN walk in. RYAN sees JORDAN – sees KARMEL and LEE – and bolts back out the door.

EXT. STREET OUTSIDE YOUTH CENTRE — NIGHT

LUCA goes after RYAN.

LUCA: Ryan!

RYAN: Leave me, man!

LUCA: I freaked out myfirst time too!

RYAN: DON'T TOUCH ME!

RYAN lashes out and knocks LUCA to the ground.

RYAN: I'm not like them, you get me? I'm not like anyone...

At that moment, JORDAN comes hurtling up and gives RYAN a massive shove. RYAN'S hits his head on a lampost...

JORDAN: Come on! Mess with my stuff! Punch me in the head! Come on!

KARMEL: Jordan!

LEE: Leave him, man!

LEE and KARMEL pull JORDAN off. Face bleeding. RYAN walks away...

JORDAN: You're weak, blood! You're weak!

INT. ISAAC'S BEDROOM — NIGHT

ISAAC and CHARLIE playing PSP. Doorbell.

INT. ISAAC'S FRONT DOOR — NIGHT

ISAAC opens the door and finds RYAN standing there, face bleeding.

INT. ISAAC'S BEDROOM — NIGHT

RYAN, wound untended, sits down with ISAAC and CHARLIE.

ISAAC: Trainers!

RYAN takes off his trainers. Irritably, ISAAC wipes the blood off RYAN'S hands and gives RYAN a game console...

INT. ISAAC'S BEDROOM — LATER (NIGHT.)

ISAAC, CHARLIE & RYAN are drinking...

CHARLIE: Jessica Alba man!

CHARLIE/RYAN: Saaweeeeeeet!

ISAAC: She's alright, nice backoff... but it's all about Da Fox!

CHARLIE/ISAAC/RYAN: Megaaaaan!

CHARLIE: Deeeeep! Ryan?

RYAN: *(Beat then...)* Kylie, Minogue, man!

CHARLIE/ISAAC/RYAN: *(Holding up their cans.)* Saaweeeeeeet!

CUT TO

INT. ISAAC'S BEDROOM — LATER (NIGHT.)

ISAAC, RYAN and CHARLIE, drunkenly slumped.

RYAN: So, If you were... gay, like...

ISAAC: I'm not gay like.

RYAN: Yeah, but if you were, like...

ISAAC: I'm not though.

RYAN: If you had to choose between gayness and death...

ISAAC: I'd choose death.

RYAN: ...If you had no choice, yeah? Who would you say was fit?

Pause.

ISAAC: Me.

RYAN: Besides you.

ISAAC: No-one's fit besides me – ain't you noticed?

CHARLIE: ...50 cent.

RYAN/ISAAC: *50 cent?*

CHARLIE: Well, If you're gonna be with a man, might as well be a *man* innit? And it might as well be a man with money.

RYAN: I dunno. I'd reckon I'd like there to be some girl in there somewhere.

CHARLIE and ISAAC look at each other.

ISAAC/CHARLIE: Gay!!!

CUT TO

INT. ISAAC'S BEDROOM — LATER (NIGHT.)

ISAAC opens his eyes to see RYAN drunkenly texting...

ISAAC: Who you texting, man?

RYAN: No one man.

ISAAC: You got a sweet boom ting, is it?

RYAN: Nah, man.

ISAAC: Don't lie! That's where you were, innit?

RYAN: Maybe...

ISAAC: Just wrong, man. Bros before hoes, bruv... Bros before hoes...

ISAAC drifts off back to sleep. RYAN presses send...

INT. TEG'S BEDROOM — NIGHT

TEGS is reading in bed. His phone bleeps. He picks it up. The screen reads 'Unknown' and a one word message 'Sorry'

INT. ISAAC'S BEDROOM — NIGHT

RYAN sleeping, is suddenly wakened with a blow to the face... He is stunned, then another blow, knocks him off the bed onto the ground. ISAAC is punching RYAN in the face, RYAN'S phone is his clenched fist.

ISAAC: You queer! You queer!

CHARLIE: Isaac man! What you on, bruv?

ISAAC: He's a battyman! He's a dirty battyman! Dutty chi-chi! Dutty faggot! Dutty queer!

CHARLIE: Isaac! You're drunk, mate! Get off him!

CHARLIE manages to get ISAAC off RYAN.

RYAN: What you talking about, man?

ISAAC: Don't talk to me, you queer! Lying on my bed – lying next to me! Lying!

(Lunging at him.)

Queer!

CHARLIE: *(Stopping him.)* Isaac!

(To RYAN.)

You better do one, man. You know what he's like when he's like this…

RYAN: I ain't…

CHARLIE: I know, man, go.

RYAN: I ain't…!

CHARLIE: Go!

RYAN runs out.

CHARLIE: What the bumba, man?

ISAAC hands CHARLIE, RYAN'S phone… On the screen is the picture of TEGS flexing in the mirror.

EXT. STREET — NIGHT

RYAN walking, battered and drunk.

EXT. STREET OUTSIDE TEGS' HOUSE — NIGHT

RYAN stands looking up at the window.

INT. TEG'S BEDROOM — NIGHT

TEGS sleeping.

INT. RYAN'S HALLWAY — NIGHT

RYAN is trying to make his way to his bedroom silently. RYAN'S SISTER looks out from her bedroom.

RYAN'S SISTER: Ryan?

She goes over to him, takes his battered face in her hands.

INT. RYAN'S BEDROOM — NIGHT

RYAN'S SISTER is tending RYAN'S face.

RYAN'S SISTER: What happened? You been out celebrating?

RYAN: Yeah. Wild night.

RYAN'S SISTER: Dad's well proud of you.

RYAN: Yeah, I know.

RYAN'S SISTER: So am I, you know. I always will be. No matter what.

RYAN: Yeah.

RYAN'S SISTER: No matter what, Ryan...

RYAN: What you saying?

RYAN'S SISTER: Nothing, just...

RYAN: What you saying? Like there's something wrong with me?

RYAN'S SISTER: Ryan, calm down, okay?

RYAN'S SISTER: There's nothing wrong with you. I'm just saying we're proud that's all... and you should be proud of yourself.

RYAN: *(Staring in space.)* Yeah, I know.

ISAAC'S STORY

EXT. PLAYGROUND — DAY

ISAAC stands waiting. CHARLIE punches him in the arm.

ISAAC: Aaaahhhh!

> *(Laughing.)*
>
> You absolute…! Right!
>
> *CHARLIE gets set for his punch.*

ISAAC: Right! Ahhh!

> *(Shaking hand….)*
>
> Dead arm! Let's do the left arm, next,
>
> yeah?

CHARLIE: Excuses! Face it you're just….

> *ISAAC punches CHARLIE in the arm, catching him unawares.*

CHARLIE: Aaaahhhh! Absolute cheat!

ISAAC: Stealth mode!

> *RYAN comes through the gate. ISAAC see him and turns his back.*

ISAAC: Okay. Now, right shoulder. Bring the fire, yeah?

RYAN comes over and stands near them.

CHARLIE: Alright?

RYAN: You cool?

> *CHARLIE hesitates, ISAAC punches him in the arm.*

CHARLIE: Aaaahhhh!

ISAAC: You snooze you bruise, bruv!

ISAAC shoves CHARLIE around playfully, ignoring RYAN. RYAN turns away...

ISAAC: Faggot.

RYAN stops for a moment then keeps walking... A can hits him in the shoulder.

RYAN: I ain't gay!

ISAAC ignores him. RYAN turns away. Another can. He keeps walking.

INT. DANCE & DRAMA STUDIO — DAY

The class doing a dance routine. ISAAC is glaring at RYAN. He gets in RYAN'S space and deliberately bumps him.

LORIS: Isaac!

RYAN moves away... ISAAC follows him. Bumps him again. Again. RYAN shoves him back and they fall into a scuffle, rolling on the floor. LORIS separates them.

LORIS: You have got exactly thirty seconds to tell me what the hell's going on here.

ISAAC: He's in my space!

LORIS: Since when did you have space, Isaac?

RYAN: I ain't queer!

ISAAC pulls out RYAN'S phone.

ISAAC: What's this then?

RYAN grabs at the phone. Another scuffle, people separate them.

ISAAC: He's got pictures of Tegs all over it! He's a battyman! You're a battyman! Battyman! Battyman!

INT. DANCE & DRAMA STUDIO — DAY

JUMPCUT THRU: Two separate meetings. ISAAC AND RYAN sit slumped.

LORIS: ...Ryan...? ryan ...Isaac? Ryan's still your friend, you know – The only thing that's changed in your relationship is you.

ISAAC: He weren't a battyman before.

LORIS: Whatever he is now he was before trust me. The difference is now you know him a bit better. Ryan. Do you need to talk to someone?

RYAN: I'm talking to you, innit.

LORIS: Well, what do you need to talk to me about?

RYAN: Nothing.

LORIS: Well, if you did need to talk to me, I would try and understand. try. I'm here help you, not to judge you.

RYAN: You can't help me.

ISAAC: Am I expelled, yet?

INT. ISAAC'S BEDROOM — DAY

ISAAC playing PSP alone.

Front door opens then slams. JACEK bursts in the room and drags ISAAC off the bed.

ISAAC: What you doing? Leave me man! Leave me!

JACEK: You get kicked out!

ISAAC: I never!

JACEK: I tell you if you get kicked out, I kick you out!

ISAAC: I ain't been kicked out, I been suspended!

JACEK: They don't want you. Everyone kicks you out, because you are animal. Is why your mother leave, it's why she never come back!

ISAAC: She left because you're a psycho! That's why! Because you treat everyone like crap!

JACEK drags ISAAC out towards the street...

JACEK: Enough! Out! Get out!

ISAAC: I hate you!

JACEK throws ISAAC out onto the street. Slams the door.

ISAAC: Give me my shoes! Give me my trainers!

JACEK sits on ISAAC'S bed, head in hands... ISAAC screams through the letterbox...

ISAAC: I hate you, I hate youuuuu!

EXT. STREET — DAY

ISAAC walking, angry. No shoes on his feet.

EXT. OUTSIDE CHARLIE'S HOUSE — DAY

ISAAC sits on wall. CHARLIE approaches.

CHARLIE: Alright?

They touch fists.

CHARLIE: Your dad go off his nut?

ISAAC: He's a chief, man.

CHARLIE: You want me to fetch you some food out?

Silence.

CHARLIE: I'd bring you in, man, but my mum...

ISAAC: No worries, yeah.

CHARLIE: Sorry, man.

ISAAC: Yeah.

EXT. FOOTBALL FIELD — DAY

RYAN is training. ISAAC watches him from a distance.

EXT. OUTSIDE LEE'S HOUSE — NIGHT

LEE playing basketball with MARIOS and ARISTOS, spots ISAAC watching them from across the road.

LEE: Just a minute, yeah...

> *LEE heads over to ISAAC.*

LEE: You lost or summink?

> *(Seeing his face.)*

> ...Isaac...

ISAAC: Why did you say that you was gay that time?

LEE: Why do you care?

ISAAC: Dunno. Just asking, innit?

MARIOS: Lee?

LEE: I'm cool. I said it for Karmel. For Teggsy.

ISAAC: Teggsy ain't even queer.

LEE: I still had to say it though.

ISAAC: Did you always know? About her?

LEE: I wish.

ISAAC: You wish?

LEE: I wish she could have told me sooner. We've been mates since we was like seven. How long you known Ryan?

ISAAC: Since we were nine. Our dads went to the same English class. Obviously it was crap.

LEE: You should talk to Ryan.

ISAAC: I don't even know him.

LEE: You should come to the gay group tonight.

ISAAC: Gay group?

LEE: You don't have to be gay. You can have gay family or friends.

ISAAC: I ain't got gay friends. I ain't got gay nothing.

LEE looks down and sees ISAAC's bare feet.

LEE: Are you hungry?

ISAAC: Dunno. Is it greekified food?

LEE gives him a look. She can't help smiling.

CUT TO:

EXT. OUTSIDE LEE'S HOUSE — NIGHT

ISAAC tying up a pair of shoes that ARISTOS has lent him.

MARIOS and ARISTOS in a basketball DANCE against LEE and ISAAC, ISAAC munching as he plays. ISAAC scores – hi-fives with LEE. They smile at each other. MARIOS and ARISTOS exchange a look.

Car horn. Across the road is JAMIE and his car. LEE looks at ISAAC.

ISAAC: Laters, yeah?

LEE: Laters...

ISAAC watches as LEE grabs her hoodie and runs across and gives JAMIE a hug, before jumping in the passenger seat. ISAAC turns to find ARISTOS and MARIOS staring at him.

ARISTOS: So, you ain't one of the gay lot, then?

ISAAC: Nahh, mate! Zero tolerance zone, you get me.

ARISTOS: You know I'm gay, innit?

ISAAC gags.

ARISTOS: *(Laughs.)* Psyche!

(Winks at MARIOS.)

...'zero tolerance', bruv.

INT. YOUTH CENTRE (GAY YOUTH GROUP MEETING.) — NIGHT

ISAAC sits with the GAY YOUTH GROUP.

ISAAC: Yeah, yeah, but it ain't natural, though!

LEE/KIM: To you!

DARCY: Being straight isn't what's natural to me.

We're all different, right?

ISAAC: Man and woman were meant for each other!

KELI: Some men and some women!

ISAAC: Yeah, but everyone chose to be gay, the human race would die out!

ALEX/DARCY: People don't choose to be gay!

ALEX: Are you saying that you were bisexual to start with and you chose to be straight?

ISAAC: You're having a laugh, incha?

ALEX: Exactly! Sexuality is not a choice.

CHARLOTTE: And you're definitely heterosexual, yeah?

ISAAC: What?

LEE/KARMEL: Straight.

ISAAC: Oh! In that case – One thousand per cent!

CHARLOTTE: Then the human race isn't going to die out, is it? We've got you!

ISAAC: Not if all the girls are gay.

GROUP: Aaaahhh!

ISAAC: I mean, what's homosexuality for?

KIM: Who cares what it's for if it's not for you?

ISAAC: Okay, what about the Bible? God says it wrong.

VANDER: Actually, he doesn't.

ISAAC: He does! It's in there!

VANDER: The Bible is several books written by several people. None of whom are God. Yes, there are negative things about homosexuality in the bible, but there's also beautiful gay love stories – Jonathan and David...

KELI: Ruth and Naomi...

JONAS: And Jesus doesn't mention homosexuality at all.

DARCY: Why do people always pick the bits from the bible that make life hard for other people but miss out the bits that make life hard for themselves?

ETHAN: We're not gonna start blaming the bible for everything, are we?

DARCY: Personally I love the Bible.

VANDER: And the Bible loves you back – if you let it.

KIM: Basically most religious scriptures are open for interpretation. That's what they were written for.

JAMIE: If you don't like what your friend is or what he's becoming, you can disagree with him without judging him.

ISAAC: Who's so amazing that they don't judge no one? You lot are judging me, now, innit?

ETHAN: Are we?

ISAAC: Yeah, you are. You see me – the way I dress and what I've got to say, and you think I'm knob, straight up! Truth, yeah?
Who here thinks I'm a straight knob?

Some hands go up.

JONAS: But not because you're straight. It's because you're a knob.

JAMIE: I think you love your mate and you miss him.

ISAAC: 'Love' him? He's mymate!

JORDAN: And you miss him.

ISAAC looks at JORDAN.

JORDAN: You miss him, fam.

MARIOS: Zero tolerance? Good luck with our sister, mate...

EXT/INT. KIDS PLAYGROUND/BFI CAFE — NIGHT

ISAAC sits on the swings in the dark. His phone rings. He answers.

CHARLIE: Bruv! Where you at?

ISAAC: Doing my thing!

CHARLIE: We're down Southbank innit!

ISAAC: 'We'?

CHARLIE looks at RYAN.

CHARLIE: Yeah...

ISAAC: Don't think so bruv.

CHARLIE: You sure?

ISAAC: *(Pause.)* Yeah.

CHARLIE: Sweet. Peace, yeah?

EXT. STREET OUTSIDE BFI SOUTHBANK — NIGHT

ISAAC watches CHARLIE and RYAN saying goodbye – touching fists, bumping shoulders, going their separate ways. ISAAC follows RYAN for a bit. Bumps into RYAN...

ISAAC: Oy! Battyman!

RYAN turns and see him. ISAAC approaches.

RYAN: Nice trainers, big foot!

ISAAC: See, how bitchy you lot are? Sick, ain't they? Borrowed 'em off a friend. ...Why didn't you tell me?

RYAN: 'Cause I wanted you to be my friend, innit?

ISAAC: Is that why you picked on Tegs, like? To be in with me?

RYAN looks away...

ISAAC: I can't be friends with you, man.

Not like we were.

RYAN: I don't want it to be like we were.

Silence.

RYAN: You alright?

ISAAC: *(Choking up.)* No. I ain't. This is doing my head in. My dad kicked me out.

RYAN: Again?

ISAAC: Innit.

RYAN: You want to stay at mine? On the floor...

ISAAC: Nah, it's cool.

RYAN: Alright...

Silence.

ISAAC: How do you know you're gay? You done anything with anyone?

RYAN: No.

ISAAC: Don't lie, what nasty business you been doing?

RYAN: Nothing, man!

(Sighs.)

Nothing...

ISAAC: So it never was Kylie?

RYAN: Nah man – Zak Efron.

ISAAC: Zak Efron??

RYAN: Elijah Wood...

ISAAC: The hobbit...?

RYAN: Daniel Radcliffe...

ISAAC: Not Harry Potter, man!! No one's that gay!

RYAN: I am.

ISAAC: Jessica Alba? Rihanna? She's gota boy's haircut!

RYAN laughs, they start walking together...

ISAAC: Ah, this is deep, blood... Harry Potter...

Raatidibungle!

They walk on together...

ISAAC: Oy! Why am I sleeping on the floor? I'm the guest!

RYAN: We can toss for it if you like...

ISAAC: Eeeeasy, son!!!

CREDITS

END

FIT STAGEPLAY

Credits

Original production September 2007 – February 2010

Tegs Duncan MacInnes

Jordan Ludvig Bonin

Ryan Steven Clarke (1st tour) and Stephen Hoo

Isaac Jack Shalloo (1st tour) and Jay Brown

Karmel Sasha Frost

Lee Lydia Toumazou

Loris Rikki Beadle-Blair

Stage/tour management and lighting design
by Rob Armstrong.

Music composed, performed and produced
by Rikki Beadle-Blair, Davie Fairbanks, Joni Levinson

Remixes produced by Davie Fairbanks and Joel Dommett

Directed by Rikki Beadle-Blair

Producers 1st tour – Ric Watts for Queer Up North

2nd tour – Howard Meaden for Drill Hall

3rd tour – Gary Everett for Homotopia

Executive produced by Contact Theatre, Drill Hall,
Homotopia, Stonewall, Team Angelica & Queer Up North

MUSIC - CAST DANCE. TEGS AND JORDAN left last on stage.

GYM

TEGS fumbles the ball and drops it - JORDAN fetches it.

TEGS: *(Panting.)* I am crap!

JORDAN: You got two out of five baskets!

TEGS: You got five out of five.

JORDAN: *(Spinning the ball on his finger.)* That's practise. And confidence. You're good at dancing, yeah?

TEGS: I'm not crap.

JORDAN: Well, that's all it is, man...

JORDAN dribbles the ball, hip-hop style, bouncing it through his legs...

JORDAN: ...Rhythm, movement, your body... and a ball. Just imagine there's music, yeah?

JORDAN does a send-up ballet dance - TEGS laughs. holds out a hand.

JORDAN bounces the ball to him.

JORDAN: See, you can catch now! You're getting it! Bounce it back, yeah?

TEGS bounces the ball back to JORDAN.

JORDAN: Nice.

JORDAN bounces it back to TEGS. TEGS catches it.

JORDAN: Nice. Now, move a bit, yeah?

TEGS and JORDAN start to circle it each other, bouncing the ball back and forward.

JORDAN: Own the area, yeah? It's all yours, it's all you... all part of you - the ground, the ball, the air, it's all you... that's it, go with the rhythm...

TEGS: This is alright!

JORDAN: Keep going!

TEGS: This is cool!

JORDAN: Keep going!

TEGS: This is wicked! I'm getting it! I'm getting it!

Enter RYAN, snatching the ball in flight, swiftly passing to ISAAC as he enters.

RYAN: My ball!

TEGS: Oi!

RYAN: You're the gay!

ISAAC: You're the gay!

RYAN: You're the gay! You're so gay - you listen to Coldplay.

ISAAC: You're so gay... You sell your batty on Ebay!

RYAN: You're so gay, you go to Uranus for your holiday!

ISAAC: You're so gay, your middle name's Gay...! Gaylord!

RYAN is silent.

ISAAC: It ain't, is it?

RYAN: You're so gay you believe anything I say! Psyche!

ISAAC: That was so gay, man. ...What did you just say, Teggsy?

TEGS: Nothing.

RYAN: Did he say something?

ISAAC: I could've sworn he said something.

RYAN: Sorry, you say something, blood?

TEGS: No.

ISAAC/RYAN: Cool.

JORDAN: He said 'oi'.

RYAN: 'Oi'?

JORDAN: As in 'That's our ball'.

ISAAC: *(To RYAN.)* No he never.

RYAN: No he never.

ISAAC: You just asked him.

RYAN: I just asked him. You never said nothing, did ya, Teggsy?

TEGS: Not really.

RYAN: See, not really.

JORDAN: Well, I'm saying something. I'm saying that's our ball.

RYAN: No it ain't - it's Teggsy's. Alright if we borrow your ball, Teggsy, matey?

TEGS: It's cool.

RYAN: There you go - it's cool.

JORDAN: No it ain't.

ISAAC: Yeah it is.

RYAN: Yeah it is. Teggsy says so. See, you're new to this college, you don't know - Teggsy and me are mates from way back, We've got an understanding. We're tight, innit, Teggsy?

TEGS: Yeah, man.

RYAN: See, man? Ta, Teggsy. You're a princess. *(Hurling the ball at ISAAC.)* Game! Catch like a girl!

ISAAC: Throw like a girl!

RYAN: Argue like a girl!

They leave.

TEGS looks at fuming JORDAN.

TEGS: We can use your ball.

JORDAN: Remind, me - why can't I just murk him again?

TEGS: What would sparking Ryan solve?

JORDAN: It'd make me feel better. And make them lot think twice about messing with you.

TEGS: 'Til you're not around and then they'd start on me worse.

JORDAN: I'm always around.

TEGS: Get excluded for fighting from another college and you won't be around will you? That is what you were excluded from your last college for, innit? Jordan. We've only been mates for a term. I'd like it to last a bit longer.

JORDAN: That fool ain't fit to wipe your boots on.

TEGS: Exactly. He ain't worth it. He's just Ryan.

JORDAN: I swear, man. One punch, end of, blood.

TEGS: I like it when you talk gangsta.

They smile.

MUSIC - RYAN & ISAAC DANCE.

CLASSROOM

RYAN and ISAAC are reading FHM'S '100 sexiest babes' issue.

RYAN: Beyonce...

ISAAC: Fit. Shakira...

RYAN: Fit. Janet?

ISAAC: Fitness personified.

RYAN: Fitness incarnate. It's all about the yummmymummies.

ISAAC: Just call me the milf-man. Gwen Stefani.

RYAN: Weird.

ISAAC: Too much make-up.

RYAN/ISAAC: ...Fit.

RYAN: Pink?

ISAAC: Butters.

RYAN: Pink?

ISAAC: I don't go for chicks with bigger arms than mine.

RYAN: You'll die a virgin then. Kylie's got bigger arms than you, man.

ISAAC: Kylie's for the gays.

RYAN: Kylie ain't gay.

ISAAC: It's gay to like her though.

RYAN: Y'what? She's a girl. That's stupid.

ISAAC: You like her, innit?

RYAN: That's pants. Who told you that, your gay dad?

ISAAC: I read it.

RYAN: You learned to read?

ISAAC: That's right, Kylie Queen.

RYAN: Where'd you read that, then? Gay Times?

ISAAC: I read it off one of your mum's tattoos when I was giving her one!

RYAN: Tosser!

RYAN jumps on ISAAC. They wrestle, ISAAC laughs.

ISAAC: Don't touch us! Get off us! I'm Heterosexual! Help! Mad homo! Mad homo!

LEE and KARMEL enter. ISAAC and RYAN freeze and look round as the BOYS stare at LEE and KARMEL - who stop and stare back. ISAAC and RYAN jump apart.

LEE: You lot alright?

ISAAC: We're sweet.

KARMEL: So we see. Practicing your moves?

ISAAC: Want us to practise on you?

LEE: Pass. You lot seen Teggs?

ISAAC: He can't do what I can for you, baby girl, trust.

LEE: If I wanna throw up, I'll stick me fingers down me throat, thanks.

RYAN: He's with his boyfriend down the gym.

LEE: I wonder if they're practising their moves?

KARMEL: We can compare and contrast.

LEE: Summink tells me they'll be a lot less gay.

KARMEL and LEE turn and leave.

ISAAC/RYAN: Lesbians.

RYAN: You reckon they are gay?

ISAAC: Lee and Karmel? Nah. Lee'd like to be but she likes lipstick too much.

RYAN: I mean Teggsy and J.

ISAAC: Teggsy's obviously woopsy. Jordan's just desperate for a mate.

RYAN: You reckon?

ISAAC: I'd like to say Jordan was gay - in fact I'm spreading the rumour to anyone'll listen - but it's obvious he ain't. You've seen him play football.

RYAN: So you can't be gay and be good at football?

ISAAC: Basic physics, mate.

RYAN: But if he's good at football...

ISAAC: ...and basketball...

RYAN: And basketball...

ISAAC: And break-dancing...

RYAN: If he's good at all of that, why's he desperate for friends?

ISAAC: Stinks.

RYAN: Come again?

ISAAC: Jordan stinks. Ever been next to him in the changing rooms? He's like a dead rat in a heat-wave.

RYAN: Jordan?

ISAAC: Stinks. It's an African thing, man - they all eat alligators and anteaters and aardvarks and that. Digestion's buggered - every fart punches a hole in the ozone.

RYAN: I've never smelt him.

ISAAC: You ain't been near him. J ain't gay. Just rank.

RYAN: But Teggsy...

ISAAC: Definitely. Have you seen him play football? Forget 'kicks like a girl'. He even falls over like a girl.

RYAN: Girls can play football.

ISAAC: Yeah, gay girls. Ain't just the football. He's just gay. He's all... soft and that.

(Shudders.)

Gay. He's so gay he makes you look straight.

RYAN: You're so gay George Michael's hairdresser bitch-slapped you and you ran away.

ISAAC: You're so gay you're gayer than Mr Dawes's pink tracksuit in the gay pride parade!

Enter LORIS, who catches the ball.

ISAAC/RYAN: Y'alright, Mr Dawes?

LORIS: Always a pleasure, gentlemen. But today you're clearly determined to spoil me. Not only on time but first in line. Run-Late Ryan and Isaac the Absent. Why verily, my cup runneth over.

ISAAC: On time?

LORIS: For the trip to the dance competition? On yonder bus?

ISAAC and RYAN look.

ISAAC/RYAN: Oh yeah...

LORIS: You did remember?

ISAAC/RYAN: Oh yeah!

LORIS: You brought your tracksuits?

ISAAC/RYAN: Yeah!

LORIS: And you ate breakfast?

ISAAC: Still got some Coco-pops stuck in me teeth, wanna look?

LORIS: No more treats, please, I might come to expect 'em. On the bus then. After you.

ISAAC: Is that so you can check out our bums as we climb on board, sir?

LORIS: It's so I don't have to see your zitty little faces. Avanti gentlemen. ...that's Italian.

MUSIC - CAST DANCEWITH BASKETBALL

GYM

The basketball hits TEGS in the head. Stunned, he goes down.

JORDAN: Tegs, man!

JORDAN rushes to stand over his mate.

JORDAN: Tegs? You alright?

JORDAN puts his ear to TEGS'S lips. Then to TEGS'S heart.

TEGS: Still beating. I'm still here.

JORDAN: Oh my days, man! You had me cacking meself there.

TEGS: It's just a ball in the head. My skull ain't that soft. I just
fancied a lie down. I'm knacked.

JORDAN: You ain't supposed to head a basketball.

TEGS: I was trying to be creative innit. Own the ball. I got
carried away.

JORDAN: That's alright. That's good. You were in the moment.

TEGS: It's alright down here. There's a breeze.
Best thing about the ground is no further to fall. Was my
heart proper racey?

JORDAN: Well manic. God knows what mines is like...

TEGS: Let's have a listen.

*Their eyes meet for a moment, then JORDAN slides round do TEGS
can listen to his heart.*

TEGS: It's bleedin' tap-dancing!

JORDAN: Breaking actually. In a good way.

TEGS: Your heart's breaking, mine is popping.
They should have their own dance team.

JORDAN shifts a bit more until they are top-to-tail, and he put his ear to TEG'S heart. They listen.

LEE & KARMEL enter - they do not see them.

KARMEL: Teggsy!

LEE: That Ryan and Isaac - Lying pair of losers.

KARMEL: They were here. I can still smell Teggsy.

LEE: You're mental.

KARMEL: I can. It's something he wears.

LEE: Mixed with sweat.

KARMEL: Don't! You know that's a sign of proper fitness, yeah?

LEE: You what?

KARMEL: It is! Profuse sweating is an indication that the system is functioning.

LEE: What you on about?

KARMEL: Fit people sweat much earlier. Their body knows that demands are going to made.

LEE: You've been reading books. Again.

KARMEL: Don't tell no-one will ya? It'll ruin me image.

LEE: Actually I sweat quite a bit meself, you know, when no-one's looking.

KARMEL: Thanks for sharing...

LEE: I'm sweating a bit now as it goes...

KARMEL: Way too much information...

LEE lifts an arm and thrusts her armpit into KARMEL'S face.

LEE: ...See?

KARMEL: Ahh!

KARMEL: Urrrrr! Oh my days, man! Noxious fumes!

LEE: So, I'm fit then?

KARMEL: Whatever.

The girls look at each other, the air is awkward...

LEE: As fit as Teggs?

KARMEL: I dunno. You don't smell like him.

LEE: He smells better, does he?

KARMEL: No. Just different. He smells of Teggs.
And you smell of you. This conversation's weird.

LEE: All conversations are weird. You really like him, don't
you?

KARMEL: Everyone likes Teggsy. Well, everyone should.
Teggsy's proper sweet. He really talks to you.

LEE: And listens.

KARMEL: Takes strength to be that gentle. To be in touch with
your masculine and your feminine side.

LEE: Sounds a bit like me.

KARMEL: 'Cept you're not gay.

LEE: How do you know?

KARMEL kisses LEE.

KARMEL: That's how I know.

LEE and KARMEL stare at each other - both in shock.

LEE: Oh my days!!

KARMEL: Oh my days...

LEE: You kissed me.

KARMEL: I know.

LEE: Why'd you kiss me?

KARMEL: I don't know.

LEE: Why'd you kiss me though?

KARMEL: To make a point.

LEE: Why'd you kiss me though?

KARMEL: To shut you up.

LEE: Why'd you kiss me though?

KARMEL: Because you're not gay.

LEE: Why'd you kiss me though?

KARMEL: Because I am.

Silence.

LEE: You're gay?

KARMEL: I think.

LEE: You're gay?

KARMEL: Probably. Possibly. Maybe. Yeah. Definitely. I'm gay.

LEE: You're not gay.

KARMEL: I am.

LEE: You're not gay.

KARMEL: Lee, I'm gay.

LEE: You're not gay. 'Possibly'. 'Probably'? 'Maybe'? 'You think'?

KARMEL: I know.

LEE: How do you know?

KARMEL: I just know.

LEE: You're seventeen, how do you know?

KARMEL: Because I wanted to kiss you - even though I knew you'd not kiss us back. Even though I knew it would turn everything mental. I wanted to kiss you. Just in case you wanted me to. So I did.

LEE: ...and...?

KARMEL: ...and it was alright.

LEE: Alright?

KARMEL: It was nice.

LEE: 'Nice'?

KARMEL: It was lovely.

LEE: Better than with a boy?

KARMEL: Kissing boys is like going on holiday in April - bit warm, bit wet, bit different - but nothing to write home about. Kissing a girl was like coming home.

LEE: Oh my days you are so totally gay! My best friend is so totally gay! That's so cool! I am totally the coolest girl in school! Can we tell people? Well, not people - but can I tell mum? Maybe not mum- but can we tell Mr Dawes?

KARMEL: What for?

LEE: I dunno. He might know things... about how to be gay n'at.

KARMEL: Only he's a man, though.

LEE: So?

KARMEL: You know what men are like, they don't take girls serious. Boys are gay, girls are just messing about. Snogging for their entertainment n' that.

LEE: Mr Dawes ain't like that.

KARMEL: I don't want to tell Mr Dawes.

LEE: Okay, we won't tell no-one then. Just us. So is this your coming out? Am I your first kiss? Raaaa!, I'm getting cooler by the minute!

KARMEL: Lee...

(Starting to cry.)

Lee....

LEE: Karmel, man? You alright? You don't have to cry, babe... it's alright. Nothing's changed, alright?

KARMEL: I want it to though. I want it change. I don't want to feel like this...

LEE: Like what?

KARMEL: I don't know... weird. I don't want to feel weird. I just want to be normal. I want to wake up in the morning and walk around being normal and like everyone else, not thinking and wondering about who or what I am. I just want to get on with it.

LEE: You are normal. You're more normal than me.

KARMEL: Only I'm not though, am I? I kiss girls.

LEE: At least you're good at it.

KARMEL: Am I?

LEE: You're good at everything. That's why I'm your mate. So you're not officially fully gay then... Just applying for your provisional licence? Well.. you've passed your oral exam.

KARMEL: You're mad, you.

LEE: So when we going to a gay bar? We can double-date with Tegs and J.

KARMEL: You reckon Jordan's gay?

LEE: Duh! Have you seen the way he looks at Teggsy?

KARMEL: Like it's Easter and Teggsy's a white chocolate egg?

LEE: If Jordan ain't gay, he should be.

>*(Smiling at KARMEL.)*

>All the best people are. ..You alright?

KARMEL: How's me make-up?

LEE: Perfect. As usual.

KARMEL: Then I'm alright. ...Bus?

LEE: Race ya!

>*They run off. JORDAN and TEGS emerge...*

JORDAN: Someone's got a fan club.

TEGS: Whatever. ...I'm sorry, mate.

JORDAN: For what?

TEGS: People thinking you're gay. That's so stupid.

JORDAN: People think you're gay.

TEGS: That's different, though.

JORDAN: Is it?

TEGS: Yeah, I'm... crap at football.

JORDAN: That's stupid too. And what's stupid enough for you is stupid enough for me.
And even if I was gay, it wouldn't be nothing to be ashamed of, would it?

TEGS: Why should it be?

JORDAN: Exactly. Let them think what they like. We know what we are, yeah?

TEGS: Yeah.

JORDAN: Well, we know about you.

>*(Smiling.)*

Apparently you're proper sweet.

TEGS: Jordan.

JORDAN: Apparently you're a listener.

TEGS: Leave it out, willya?

JORDAN: And... a bit of a sweaty bugger.

TEGS: 'Cause I'm fit.

JORDAN: Oh yeah?

TEGS: Er.. Yeah!

TEGS runs for the bus...

JORDAN: Oy!

Laughing, JORDAN goes after TEGS, who suddenly stops.

TEGS: Wait!

JORDAN: What?

TEGS: We shouldn't go together.

JORDAN: You what?

TEGS: To the bus. We should arrive separate. We shouldn't always be together.

That's what's giving people the wrong idea all the time.

JORDAN: Who gives a monkeys?

TEGS: They do.

JORDAN: Cool.

TEGS: Cool?

JORDAN: Whatever, man. Sweet. Can we sit together, though?

TEGS: Deal. You go first.

JORDAN: Cool.

MUSIC - CAST DANCE - BUILDING THE BUS

BUS

RYAN: Isaac, man?

ISAAC: Ryan man...

RYAN: If you were... gay, like...

ISAAC: I'm not gay like.

RYAN: Yeah, but if you were, like...

ISAAC: I'm not though.

RYAN: If you had to choose between gayness and death...

ISAAC: I'd choose death.

RYAN: ...If you had no choice, yeah? Who would you say was fit?

ISAAC: Me.

RYAN: Besides you.

ISAAC: No-one's fit besides me - have you not noticed? ...50 cent.

RYAN: 50 cent?

ISAAC: If you're gonna be with a man, might as well be a man innit? And it might as well be a man with money.

RYAN: I dunno. I'd like there to be some girl in there somewhere.

ISAAC: You are so gay. 'Some girl in there somewhere'? Like Sir, you mean?

They grin at LORIS'S back. He does not look round.

RYAN: Not that much girl... Sir!

LORIS: You're 17, Ryan. This is sixth form college. You don't have to call tutors sir.

RYAN: Sir!

LORIS: Yes, Ryan.

RYAN: Are we there, yet?

LORIS sighs.

ISAAC: Are we leaving soon, sir? Or are we waiting for the latecomers sir?

LORIS: It's not ten o'clock yet.

ISAAC: So them lot ain't late?

LORIS: No.

ISAAC: So that means... We're...

LORIS: Early!

RYAN/ISAAC: Eaarlyyyyyyyyy!

ISAAC: Sir, this air-conditioning is crap!

LORIS: It only works when the engine is running.

ISAAC: That is so gay, sir!

RYAN: Are we annoying you, sir?

ISAAC: Do you wish we were late now, sir?

LORIS: And miss all this sparkling banter? Kill me first.

KARMEL and LEE arrive on the bus. They swan past RYAN, JORDAN & ISAAC without looking...

RYAN/ISAAC: Alright?

LEE/KARMEL: *(Uninterested.)* Alright?

(To LORIS, friendly.)

Alright, Loris?

LORIS: Good morrow, ladies...

JORDAN stomps screw-faced onto the bus.

LEE/KARMEL: Y'alright, Jordan.

JORDAN: Alright...

KARMEL: Where's Teggsy?

JORDAN: How should I know?

TEGS arrives.

KARMEL: Teggsy!

LEE/KARMEL: *(Super-sweetly.)* You alright?

TEGS: Alright?

KARMEL: There's loads of room down here!

TEGS: Oh, sweet!

ISAAC/RYAN: *(Mimicking.)* Aw, sweet!

JORDAN turns to them.

JORDAN: Y'what?

TEGS: *(Quietly.)* Jordan...

LORIS: Can we be seated, people? I'd like to get there and back in the same decade, if that's alright.

TEGS: Come on.

JORDAN follows TEGS to his seat, staring RYAN and ISAAC out.

RYAN/ISAAC: Y'alright?

JORDAN says nothing.

RYAN: *(Tres camp.)* You alright, Teggsy?

TEGS: ...alright?

LORIS: Quick driver, before anymore turn up.

The bus starts.

MUSIC - CAST DANCE

Everyone sits in silence. LORIS picks up a small bullhorn and announces...

LORIS: Right!

> *EVERYONE - including LORIS - jumps and winces...*

LORIS: *(Through bullhorn - softer...)* Right... there is a toilet on this bus - please use it and refrain from piddling in bottles and chucking 'em out of the windows, because last time someone got arrested and they were never seen again. We shall be stopping for luncheon at the famous Angel of the North Statue, where there are no cafes or kiosks, so I strongly advise you not eat your lunches until then. Meanwhile, no fighting, no shouting, and please God, no singing, I'm trying to read my comic down here. Thank you for not listening!

> *EVERYONE pulls out their lunches except ISAAC. ISAAC looks at him.*

RYAN: Where's yours?

ISAAC looks away.

RYAN: That's so gay, man...

> *RYAN gives ISAAC his sandwiches.*

RYAN: Oy, Teggsy!

TEGS: Yeah, mate?

RYAN: I'm hungry. You got a sandwich?

LEE: You are joking?

JORDAN: Where's yours?

RYAN: Blimey, Teggsy, your voice has changed. I didn't even realise that was you. I forgot mine.

JORDAN: Tough.

RYAN: What's that, Teggsy?

KARMEL: Don't give him nothing.

LEE: Blank him.

TEGS gets out a sandwich. JORDAN stares angrily.

TEGS: It's just a sandwich.

JORDAN: It's your sandwich.

TEGS: I ain't hungry.

He gives it to RYAN.

RYAN: Ta, princess.

RYAN goes to bite.

JORDAN: Bite that and you're dead.

RYAN pauses, staring JORDAN out, then takes the almost-bite further...

JORDAN jumps up to standing.

JORDAN: Your teeth touch that and you'll be carrying 'em home in a bag.

RYAN bites. JORDAN hurls his sandwiches at RYAN.

ALL KIDS: Oooooh!

ISAAC: Hostilities commence!

LORIS: Mr Jordan!

THE KIDS all snap into innocent inattention except a still-burning JORDAN.

LORIS: Would you like to sit down here with me?

JORDAN: Not really.

LORIS: I'll rephrase that. You're sitting here with me.

JORDAN: I want Tegs to come.

LORIS: Shame Tegs ain't invited. This is your own special little treat for being such a model student.

JORDAN: *(Quietly to TEGS.)* Stay sitting with the girls, yeah?

TEGS: *(Embarrassed.)* Jordan...

JORDAN: Just holler if you need us, alright?

He moves down to sit with LORIS.

LEE: He better not get in trouble because of you, Ryan.

RYAN: What the hell have I done? All I wanted was a sandwich and he goes militaristic. He's a nutter.

ISAAC: He's a bully.

RYAN: He's a big bully. I'm traumatized....

(Picking up the wreckage of JORDAN'S sandwich.)

Luckily for him, I'm also starvin' and in need of this sandwich or I'd have the energy to kick his narrow little buttocks up his batty-hole.

LEE: You're repugnant.

ISAAC: Don't mock the hungry, Heartless.

KARMEL watches TEGS watching JORDAN.

KARMEL: You alright, Teggsy?

TEGS: I'm fine. I downloaded that new Adam Lambert video for you onto me ipod.

The GIRLS squeal.

LEE: Oh myGod!

KARMEL: You are so the download demon! I wish I had Limewire pro! Can we have a listen on the headphones?

TEGS: *(Smiling.)* Oh, go on then...

RYAN watches LEE and KARMEL huddled with TEGS, sharing his headphones and watching his video ipod.

RYAN: Adam who?

ISAAC: Lambert.

RYAN: Oy! Lee!

LEE: That's my name, now guess me number.

RYAN: Adam who?

LEE: You wouldn't know him. No guns in his videos.

(To TEGS.)

Rewind that bit, Tegs babes...

RYAN: Adam who?

ISAAC: He's that gay one, innit? You know - kissed a bloke on MTV.

RYAN: Is that why Teggsy likes him? Is that why you like him Teggsy? 'cause he's one of your people? Do you fancy him? Is he fit? Is he fitter than me?

KARMEL: Die, Ryan.

ISAAC: Oh, man! Shame!

RYAN: I'm just asking. I'm just trying to understand, to sympathize, to empathize...

RYAN puts an arm around TEGG'S shoulders... JORDAN looks back...

RYAN: ...I want to bond.

JORDAN: Oy!

LORIS: Jordan! Sit!

RYAN: I just wanna know - is this love for Adam Bumbert a sisterhood thing or what?

...Teggsy?

(Sing-song.)

Teggsyyyy!

LEE: Don't answer him.

TEGS: I just like his music.

RYAN and ISAAC look at each other.

RYAN/ISAAC: Gaaaaaay!

KARMEL: So what if he is gay?

RYAN: You saying Teggsy's gay?

KARMEL: No. But what if he is?

ISAAC: She's saying he is gay, man.

KARMEL: No. I'm saying if he is, what's it to do with you?

ISAAC: Why's she speaking for him, man?

RYAN: Why you speaking for him?

ISAAC: Ain't he got a tongue?

RYAN: Can't he speak for hisself? You can speak for yourself, can't you, Teggsy? You're your own man.

TEGS: Course I can.

RYAN: Right. So. Man to man and that - are you a bum bandit?

KARMEL: I think the real question is why are you so interested?

LEE: Know what I mean?

RYAN: Who knows? Maybe I'm looking for a boyfriend.

TEGS: Dream on.

RYAN: You what?

ISAAC: Ohhhhhhh! Man! It burns!

RYAN: You what?

TEGS: Just joking, mate.

ISAAC: Oh, he's your mate now! Slaps you down with a smile!

RYAN: 'Joking'? I got feelings, mate. I ain't a robot. I'm sensitive. That hurt. Here's me trying to connect and you casually brush me off. That's well bad, man.

ISAAC: Well bad, man. If that were me, man, I don't know what I'd do.

LEE: Well, it ain't you so 'low it.

TEGS: I was just having a laugh, Ryan, man. If I hurt you I'm sorry.

RYAN: I'm like you, Teggsy. Soft. If I scarred you like you just scarred me would sorry be enough?

TEGS: Well, you've never said sorry to me - so I dunno - but maybe yeah.

RYAN: You reckon?

TEGS: Well, sorry might be a start.

RYAN: Well, that's 'cause you're gay, innit? So what's this Adam geezer sound like? G'is a listen.

LEE/KARMEL: Do one!

TEGS: No, it's alright, he can have a listen. I've got another set of headphones...

ISAAC: So that's it, then? You're just gonna let him mug you off and leave it at that?

RYAN: No. Just...

ISAAC: How gay on a scale of one to ten are you, man?

RYAN: He ain't mugging me off.

ISAAC: You look prettymug-shaped from where I'm sat. ...Well?

TEGS approaches with the headphones.

TEGS: Here you go, mate.

RYAN: You mugging me off, Teggsy?

TEGS: What? No.

RYAN: I think you are. Slapping me down then fobbing me off with headphones. I think you're putting me on an abuse cycle. I ain't having it. Right. When we get to Newcastle, we're having this out.

TEGS: You what?

ISAAC: *(Flicking paper balls at TEGS.)* You heard!

RYAN: You heard. You and me...

ISAAC: *(Flicking paper balls.)* ...You and him...

RYAN: ...Face to face...

ISAAC: *(Flicking.)* ...Face to face...

RYAN: ...one on one...

ISAAC: ...one on one...

RYAN: ...man to man.

ISAAC: Actually dude, that comes over a little bit gay.

KARMEL: Sod off, Ryan. He's not fighting you.

RYAN: Who's said anything about fighting? I'm just booking a meeting.

LEE: He's ain't meeting you.

ISAAC: There they go again.

RYAN: See, there you go again. Not letting poor Tegs get a word in or think for hisself. You're not scared of little ol'

me are you, Teggsy, sister? I just want to sort things out. Or are you throwing that back in me face an' all?

TEGS: No.

RYAN: So?

TEGS: Cool.

(Looking calmly at RYAN.)

We'll sort things out.

RYAN: Sweet.

(Winks.)

Can't wait.

LEE: Don't worry babes, Jordan'll sort him out.

KARMEL: Wait 'til he finds out, he'll go mental.

TEGS: Not if you don't tell him, he won't.

KARMEL: I'll tell him now - what's his mobile number?

TEGS: Leave it Karmel, it's fine. It'll just get worse. I can sort this.

LEE: How? By eating one of Ryan's knuckle sandwiches? You ain't a fighter, Teggsy. Let Jordan sort it.

TEGS: I don't want Jordan in trouble. Promise me you won't say nothing to him.

LEE/KARMEL: *(Mutter.)* Promise.

TEGS: What's that?

LEE/KARMEL: Promise!

TEGS: That's my girls... Now, sod Ryan and his poodle-slash-boyfriend, back to Adam, yeah?

The girls look at each other, then reluctantly don the headphones.

BUS - later

JORDAN is looking round to see what's going on. See LORIS staring at him. He slumps back into his seat with a scowl.

LORIS: So you gonna talk to us then?

JORDAN: About what?

LORIS: Oh, I dunno - You making mayhem at the back of the bus? Forever stood about giving everyone evils? You having problems?

JORDAN: Ain't everybody?

LORIS: Are you having problems with someone in the dance team? ...Jordan, you're a brilliant dancer - why distract yourself?

JORDAN: What can I say - short attention span. Don't tell me. You're there for me if I need to talk.

LORIS: Is that wrong?

JORDAN: What good does talking ever do?

LORIS: You'll never know if you don't try.

JORDAN: Then I'll never know, will I?

LORIS: Is someone picking on you?

JORDAN: No.

LORIS: Is something going on at home?

JORDAN: No.

LORIS: My attention-span is pre-MTV, you know - I can nag for hours...

Are you worried about something? Have your testicles failed to drop...?

JORDAN: *(Cringing.)* Aww, Sir!

LORIS: Have your pubes failed to grow? Are you sprouting a third nipple?

JORDAN: Loris!

LORIS: I'm listening.

JORDAN: Alright. Can I ask a question?

LORIS: I don't know, can you? May require forming a sentence.

JORDAN: Are you... Thingy?

LORIS: Are you asking if I'm gay? Is what you want to talk to me about. Is someone picking on you because they think you're gay?

JORDAN: No. No-one thinks I'm gay. Not that you'd do anything about it.

LORIS: What?

JORDAN: You ain't doing nothing for Teggsy...

LORIS: Teggsy?

JORDAN: ...why should you do anything for me?

LORIS: That's what was going on just now?
Teggsy's getting attacked?

JORDAN: Boy, you're fast, incha? Good thing you're the teacher or you'd be bottom of the class.
Don't beat yourself up, sir - ain't your fault they're too sly stupid enough to get physical in front of you.

LORIS: So, what are they doing? Name calling?

JORDAN: Touching.

LORIS: 'Touching'?

JORDAN: Sometimes it looks like they're touching in a friendly way and talking in friendly way and it's the opposite. That way they can do it right in front of you.

LORIS looks round at LEE and KARMEL, laughing and tickling TEGS.

LORIS gets up.

LORIS: Tegs.

TEGS: Sir?

LORIS: Are you alright?

TEGS: *(Puzzled.)* Yeah, why?

LORIS: Are you sure?

TEGS: Yeah.

LORIS: I want you to go down the front with Jordan, please. Now.

LEE: Why, what's he done?

LORIS: Never mind what he's done, Missy - take responsibility for your own actions.

LEE: What have I done?

LORIS: Is that your ipod?

LEE/KARMEL: No.

LORIS holds his hand out.

KARMEL: It's not yours, neither.

LORIS: Go on, girls, push me.

ISAAC: Go on, girls, push him.

LEE: Sod off, you testicle!

ISAAC: Sir! She's picking on me!

LORIS: Shut up, Isaac.

(Hand still out.)

...Lee.

LEE hands over the ipod. LORIS takes it forward to TEGS.

LORIS: Here you go, Tegs.

LORIS sits down.

TEGS: So that's two less friends - happy?

JORDAN: He was touching you! Who's he think he is, man? Laying a hand on you? He's sick...

JORDAN reaches into his bag, checks LORIS isn't watching and pulls out a blade.

TEGS: Jordan!

JORDAN: - And I'm gonna cut the sickness right out of him.

TEGS: Put that away!

JORDAN: He don't know what sick is 'til he's messed with me...

TEGS: What the hell are you doing? Give that here!

TEGS tries to take the blade.

JORDAN: Leave off!

TEGS makes a grab and slices his hand...

TEGS: Aaah!

JORDAN: What you done?

TEGS: Nothing.

JORDAN: Did it catch you? Let me look.

TEGS: Don't! Look, just give it me.

JORDAN: I wanna see!

TEGS: Jordan. Give me that, please.

JORDAN holds out the blade - as TEGS takes it, JORDAN grabs TEGS'S hand. He looks at it.

JORDAN: Sorry, man.

TEGS: Sir!

LORIS: Sir is not a name.

TEGS: Mr Dawes. Is it alright if I change seats?

LORIS: Change buses if you like - just don't make my migraine any worse.

TEGS changes seats....

LORIS: You alright?

TEGS: Sweet.

>*Sucking on his wound... TEGS puts on his headphones, turns them on, and blanks JORDAN - who looks at LORIS.*

JORDAN: I asked you don't say nothing.

RYAN: Sir!

LORIS: Now what, Ryan?

RYAN: Can we take a detour sir?

LORIS: Are you on crack? To where? Alton Towers? We're on a schedule.

RYAN: It's Isaac, sir... he's not got his tracksuit, sir.

LORIS: He's wearing it.

RYAN: His team one, sir. He left it at home sir... He only lives a few streets away, sir...

LORIS: Stop calling me sir...

RYAN: ...it'll only take a minute. He ain't got nish to dance in, sir.

LORIS: Isaac! Where's your tracksuit?

>*ISAAC shrugs.*

LORIS: So you did forget about today?

ISAAC: No.

LORIS: Just your tracksuit. How far to where you live?

ISAAC: I think we've passed it.

RYAN: No man, it's just up ahead, left at the lights.

(Seeing ISAAC'S face.)

What, man?

LORIS: Driver! Left at the lights!

ISAAC/RYAN: ...Please.

LORIS gives them a filthy look.

LORIS: ...please.

MUSIC - CAST DANCE - THE BUS TURNS...

BUS/OUTSIDE ISAAC'S HOUSE

LEE/KARMEL: Why are we waaaaiting... Why-y are wee waaaaiting...

LORIS: Lee. Karmel.

LEE: We're running behind. We're gonna be late.

LORIS: I'm not in the mood for you two, alright?

KARMEL: Does anybody even live round here, anyway? Look at it.

LEE: You know? Proper ghetto.

RYAN: You lot shut up, yeah? You want us to go and see what's happening, Sir?

LORIS: My name's not sir. No. I'll go.

RYAN: I don't think you should. His dad is a bit...

(Lowers voice.)

ghetto.

LORIS: We'll both go.

They go round the corner and find ISAAC sitting on the doorstep.

LORIS: Don't tell me you left your keys behind an' all.

ISAAC: Don't need keys.

LORIS: Oh, aye?

ISAAC: Me trackies ain't in there.

LORIS: Where are they then?

ISAAC: In there.

ISAAC nods towards the bins.

LORIS looks in the bin. ISAAC'S tracksuit is in there, cut to shreds.

ISAAC: Me Dad reckons it's gay.

LORIS: Your tracksuit?

ISAAC: Dancing and that. Says it's pointless. Says I'm wasting me time. Reckons I'm wasting time breathing. Waste of time. Waste of space. Says me middle name's pointless.

LORIS: He don't mean that.

ISAAC: Then why's he say it, then?

LORIS: Do you want me to talk to him?

RYAN/ISAAC: No!

RYAN: You'll onlymake it worse! He ain't reasonable like you, sir.

ISAAC: He ain't in, anyway. You lot just go, yeah?

RYAN: We're not leaving you here. Sir, we're not leaving him here?

ISAAC: Why not here? This is where I live.

LORIS: Because we need you with us...

(Teasing, acting 'street'.)

Innit? er, man? We can stop on the way and sort out the tracksuit business, yeah, but we really need you to come with us Isaac, blood, you know what I mean? You're needed, spar!

(Nudging ISAAC playfully.)

You get me, homie? Y'see me fam?!

ISAAC: *(Jumping up before he laughs.)* Alright! God, this is so gay.

ISAAC heads towards the bus, turns back to see LORIS and RYAN'S concerned faces.

ISAAC: Come on then!

He gets up and leads the way back to the bus. Affectionately LORIS copies ISAAC'S street gangsta walk. ISAAC tries not to smile...

ISAAC: Whatever, sir...

ISAAC and RYAN board the bus, followed by LORIS...

LEE: You're alive then?

KARMEL: We thought you'd been eaten by the neighbourhood rats!

RYAN: Shut up.

LORIS: Driver....

BUS gets going...

KARMEL: What was his house like? Proper squalid?

LEE: Did his dad try and sell you crack?

RYAN: You lot bloody well shut it alright?

LEE: Ooops, sorry, gangsta bitch - are we dissing your ghetto thug boyfriend?

LORIS: Right! Ryan. Isaac. Down the front with me. I've had enough. I'm reporting you two homophobic little bullies.

LEE/KARMEL: You what?

LORIS: You heard.

LEE: Us? What about them two?

LORIS: What about them? What goes on between Ryan and Isaac is none of your business.

RYAN/ISAAC/LEE/KARMEL: You what?

LORIS: Sorry, Ryan, sorry Isaac. Okay. This is not the time and place for this discussion - we'll talk about this later.

KARMEL: So it's okay for Ryan and Isaac to beat up Teggsy but it's not okay for us to stick up for him?

LORIS/JORDAN: You what?

KARMEL: He reckons he's gonna have him when we get to Newcastle.

LEE: And not in a good way.

ISAAC: Grass!

LORIS: Is this true?

RYAN/ISAAC: No.

LORIS: Teggs? Teggs!

LORIS reaches across and lifts one of TEGG'S headphones.

LORIS: Mr Teggs!

TEGS: What?

RYAN: Has Ryan been threatening you?

RYAN: No!

TEGS: Threatening me?

JORDAN: You heard him. Did Ryan reckon he was gonna give you a kicking in Newcastle?

TEGS: *(To girls.)* You said you wouldn't tell him!

LEE/KARMEL: We never!

KARMEL: We told Mr Dawes.

TEGS: Oh, that's alright! Thanks!

JORDAN: Why weren't they supposed to tell me?

TEGS: You know why.

LORIS: So Ryan and Isaac said they were gonna beat you up?

RYAN/ISAAC: No!

RYAN: I never said that.

ISAAC: I never said nothing.

RYAN: I said I wanted to bond.

LEE: As in bond your fist to his face you mean...

ISAAC: Squealer.

RYAN: Shut up, man! I said I wanted to bond and Teggsy said he was cool with it.

JORDAN: 'Cool with it'?

RYAN: He even offered to let me listen to his ipod. Rufus Gaywright. We was bonding.

JORDAN: *(Looking at TEGS.)* Oh, bonding. Right.

LORIS: So you two are not being bullied for being gay?

RYAN/ISAAC: Gay?

ISAAC: You thought we was gay?

LORIS: Well, I don't know, do I? Everything's gay to you lot! Course-work's gay - bad air-conditioning's gay - lumpy custard's gay!

ISAAC: That's not 'gay' - that's gay!

LORIS: Well that explains everything.

ISAAC: I think you're taking it too literally, sir...

RYAN: When we say something's gay we don't mean it's...

ISAAC: ...wearing tight jeans and buying a Chihuahua...

RYAN: ...we mean, you know...

LORIS: ...you mean...?

RYAN: We mean something's... crap.

LORIS: Crap.

RYAN: Well not crap. Just... lame.

LORIS: Lame? As in disabled?

RYAN: As in useless. That's all.

LORIS: And that's okay?

RYAN: It's just a phrase. Everyone says it.

LORIS: Lee and Karmel never say it.

ISAAC: They do.

LEE: *(Apologetically.)* ...we do.

KARMEL: ...Just not in front of you.

LEE: We're not talking about you, sir.

KARMEL: We're not talking about anybody.

LEE: We're just talking.

LORIS: Ryan... You're of Irish descent. How would you feel if I say something's Irish when I mean something's crap..?

RYAN: People say it all the time.

LORIS: And that makes you feel..?

RYAN: Nothing. They're not talking about me. It's just a joke.

LORIS: So when people make crap Irish jokes - when they say Micks are stupid, they're not talking about you?

RYAN: Micks are stupid.

LORIS: Micks are not stupid, Ryan - Present company possibly excepted - and Irish people are not micks. And gay people are not crap.

ISAAC: He's not saying they are.

LORIS: Yes he is.

ISAAC: He's not.

RYAN: I'm not!

LORIS: Well, how am I supposed to know the difference? All I'm hearing is 'gay' 'GayGayGayGay' - and whether it means crap or homosexually-inclined it's never intended kindly. And then I've got Jordan talking to us in even more code and si I'm leaping to conclusions about Teggs and then the girls are calling you two gay and I realise you're together even more than Jordan and Teggs...

ISAAC: We're mates!

LORIS: ...and I'm hopping from conclusion to conclusion so fast it's a miracle me brain ain't got a broken leg!

ISAAC: So you can't have mates no more without being bum-chums? I mean do we look gay?

LORIS: Is that gay as in homosexual or gay as in ineffectual?

ISAAC: You know what I mean. Do we look gay?

LORIS: I don't know. What does gay look like anyway?

EVERYONE looks at TEGS.

TEGS: Why's everyone looking at me?

LEE: They're not. They're looking at me. I'm what gay looks like.

LEE takes KARMEL'S hand.

LEE: We're what gay looks like.

LORIS: What?

KARMEL yanks her hand away.

KARMEL: Lee!

LORIS: You're gay?

KARMEL: She's winding you up, sir. Blank her.

LORIS: You're both gay?

ISAAC: In her dreams!

LORIS: For pity's sake! So everyone's gay now?

LEE looks at KARMEL.

LEE: No. Just me.

LORIS: What are you on about?

LEE: I'm gay. Just me. I'm gay.

LORIS: I have absolutely no idea what is going on with any
of youse and quite frankly do not care - You can be gay
straight or bisexual, or bi-centennial or anything you fancy
as long as you are civil and sociable and silent!

(Deep breath.)

I want everyone to to calm down... I want us to get back
in our seats and focus on the matter of the day, alright? No
threatening, no flirting...

(To LEE.)

...no pretending we're gay for a laugh. How about we all
try pretending that we are actually sane human beings for
one day. Do we think we can manage that?

*Pause. KARMEL goes back to her seat and sits. LEE remains
standing.*

RYAN goes back to his seat. ISAAC sits elsewhere.

RYAN: Isaac, man?

ISAAC: I'm good over here, man.

RYAN: *(Pause.)* Cool.

TEGS and JORDAN sit separately. They put their ipods on without looking at each other. LEE is looking at LORIS.

LORIS: Now what?

LEE: Why did you think I was pretending?

LORIS: Pretending?

KARMEL: When I said was gay. Is it because I'm a girl?

LORIS: You what?

LEE: You said you thought that the boys were gay 'cause they're together all the time. Me and Karmel are together all the time - or have you not noticed?

LORIS: Well, yes, but...

LEE: ...but its different for girls? 'cause boys are definite - girls are wishy-washy? Boys are totally straight or totally bent and girls are just messing about til they meet a babymaker? I know your job ain't easy. I know kids say and do stupid things, and I know kids have always been cruel. And I know there ain't no teacher's manual about what to do when we chuck words like gay about all random like. And I know you can't save us from a world full of small minds. But I was hoping that you wouldn't just ignore us. Anyway... whatever, yeah?

LEE goes back to her seat - LORIS thinks.

MUSIC - CAST DANCE - DOZING. AND TRAVELLING...

BUS/ANGEL OF THE NORTH

LORIS produces his bullhorn and announces...

LORIS: We are now arriving at the world-renowned landmark and example of modern art , 'The Angel of the North' where we shall be stopping for a brief luncheonette. Please

do not attempt to climb the statue, urinate or defecate on the statue or take pieces of the statue home as pointless souvenirs, 'cause if the police arrest you I will claim to have never met you in my life and instruct the bus to depart immediately leaving you to their mercy. You have thirty minutes. Thanking you.

The KIDS look out the window.

RYAN: Is that it?

LORIS: I know. It's a bit straight, innit?

The KIDS look at him. LEE gets up.

LEE: Is there a lav? I'm busting.

LORIS: God, that is so straight. No bladder control. It's over there. Where all those sad straight- looking people are stood about in a straight queue.

ISAAC: Alright, Sir, you don't have to overdo it, we get the point.

LORIS: What point? It's just a figure of speech. Don't take it personally,

(Through the bullhorn....)

straight boy...!

(No bullhorn.)

...I'm not talking about you.

ISAAC: You are talking about us, though, to make 'a point'.

LORIS: Whether I'm talking about you or not,

(Bullhorn.)

Straight boy!!!

(No bullhorn.)

it's still annoying, isn't it..

(Bullhorn.)

Straight boy!!!!!

ISAAC: Because it's stupid.

LORIS: Exactly,

(Bullhorn.)

Straight and stupid - Harry Hetero!!!!!

ISAAC: Are you allowed to do this sir? Shoving your sexuality down our throats - talking about it like it's normal and that? We're young, sir, we've impressionable minds. We might get influenced.

LORIS: Are you saying you could be influenced, young Mr Isaac? Are you saying your heterosexual credentials are a wee bit dicey? Should we be discussing your...

(Bullhorn.)

...sexual confusion in an impromptu workshop?

ISAAC: No.

LORIS: *(Whispers.)* Oh ok... we will not be discussing...

(Bullhorn.)

...Isaac's sexual confusion in an impromptu and very private and special workshop.... Twenty four minutes, breeders!

The DANCE TEAM starts to troop off the bus....

ANGEL OF THE NORTH

KARMEL stands alone. LEE approaches.

LEE: You alright?

KARMEL: I'll let you answer that question for me, seeing as you're my spokeswoman.

LEE: I'm sorry babes, I didn't mean to out you.

KARMEL: *(Sarky.)* Didn't you? Oh well, oops. So - it's official, you are now definitely the coolest girl in school - A militant lesbian and you're not even gay.

LEE: Oh, ain't I? Thanks for the diagnosis, Dr Karmel.

KARMEL: Lee, this ain't a game - this is my life. I'm not being gay to be cool or for a laugh or to keep me best mate company. I'm gay because I have no choice. The one choice I have got is who I can tell. And when. I know I should stand up for Teggsy and for meself and for everybody. I know I should be brave. And one day I will be. In my own way and me own time. You get me?

LEE: I get you. So do you hate me now?

KARMEL: How can I hate you? You're the coolest girl in school... I'm starving. Got any lunch left?

LEE: I got mints.

KARMEL: Go on then.

TEGS approaches a solitary JORDAN.

TEGS: You alright?

JORDAN: I should have said something.

TEGS: About what?

JORDAN: About me. When Lee spoke up. I should have said it. 'I'm gay too.'

TEGS: Why?

JORDAN: 'Cause it's true. I should have stood up and said it - loud and proud and sod everyone else.

TEGS: It's alright for Lee and Karmel. It's different for girls.

JORDAN: Yeah.

TEGS: They're probably not even gay anyway. Is that why you got chucked out of your last college? For suspected gayness?

JORDAN: No. I got kicked out for fighting - like I told you.

TEGS: See, that's why I never told you about Ryan. 'Cos you'd kick off.

JORDAN: I was in love.

TEGS: Y'what?

JORDAN: With a lad called Melvin. He was lovely. Dead skinny, but lovely. He was out. He was proud. And they used to knock seven bells out of him. They used to spit on his back from the top of the stairs. They used steal his stuff and piss on it and worse. And he was like you. He never cried. They did some right horrible things. Constantly. Just torturing him. And I used to let 'em. I used to watch. And I never said nothing. Til one day, he tried to kill hisself. Tried to hang hisself with his shirt in the changing rooms while the rest of us was playing football. I don't know why he choose the changing room. Yeah, I do. So we'd find him there. So we'd discover him. It was meant to be his final statement. But he didn't die. Just nearly. Ambulance came. Took him away. And people started laughing about it. Straight back to taking the piss. Someone found Melvin's bag - started to kick it about. And I snapped. I went mental. I broke this lad's cheekbone. I'm not sorry. He deserved it. I deserved it. I was another coward just like them. When I should have been brave like Melvin.

TEGS: You know what, sod you, Jordan. You don't know me.

JORDAN: You're right.

TEGS: Sod you, you don't! Be as sarky as you like - but you don't! You're just as bad as everyone else - You look at me - and 'cause I'm crap at football, 'cause I'm crap at basketball, cause I can't shave properly, and I'm not a bloody macho-meathead you think you know me - When

I don't even know me. I'm not Melvin, alright? I'm me. Well, I'm trying to be. But I've got everyone telling me what I'm supposed to be, how I'm supposed to act - everyone thinks they know me better than I know myself, I'm so busy trying to survive, I've got no time to sort out who I am. I've practically never even kissed nobody. How am I supposed to know what I am?

JORDAN: You can kiss someone now if you want. If it helps.

TEGS: You mean... you?

JORDAN: Or not. If you don't want. You probably don't need to. I didn't need to. I wanted to. I thought about it. I practically thought about nothing else. But I didn't need to. One look. At you. One look... I knew. I used to think, 'maybe...' 'probably...' but one look at the real thing, I knew.

TEGS: I'm the real thing?

JORDAN: You know you are. So you wanna kiss us or what?

TEGS: Here?

JORDAN: Right here, right now.

TEGS: I can't, mate.

JORDAN: Can't kiss me here? Can't kiss me now? Or can't kiss me?

TEGS: Why should I kiss you?

JORDAN: I dunno. Cause you want to?

TEGS: What if I don't want to? It's not my duty to be gay, so you're not lonely, Jordan, mate. Even if I am gay, why should I want to kiss you just because you say you're gay too?

JORDAN: Yeah, why should you? When there's Ryan?

Silence.

JORDAN: ...And your little meeting that had to be kept secret from me? Maybe he'll kiss you if he don't give a kicking. Go on - now tell me I don't know you. Tell me you don't want to kiss him.

TEGS: I just want him to leave us alone. I just want everyone to leave me alone.

JORDAN: Fine. You're alone. Happy?

JORDAN walks away.

RYAN approaches TEGS.

RYAN: Lover's tiff? This a bad time? You probably want me to sod off, doncha? You probably hate me.

TEGS: I probably should - seeing as you hate me.

RYAN: I don't hate you. I swear, man, some days I tell myself I'm gonna leave you alone - And then you're there and it's like a bad habit. You know how kids step on worms to see what will happen?

TEGS: I'm a worm?

RYAN: No. You ain't a worm. It's like picking a scab when you know you should leave it alone.

TEGS: I'm a scab?

RYAN: No. You're just soft. It makes me want to wind you up. That's all it is. It's not meant to hurt. Not really. I know it does, but it's not meant to. ...But it does, yeah?

TEGS: Yeah.

RYAN: See you're doing it again. Being all soft.

TEGS: Making you wanna hit me?

RYAN: No.

(Pause.)

...chewing gum?

Pause. TEGS takes the gum.

RYAN: Can I ask you a question?

TEGS: Go on.

RYAN: Do you reckon Jordan's...? I know he's your best mate and that, but do you think he's a bit... It's just the way he is around you. When I talk to you. Like he's... jealous or something stupid like that. Now, he really hates me. No sense of humour, that's his problem. Shame. He'd be a good mate.Has he... tried anything? With you, like?

TEGS: No.

RYAN: I think he wants to. The way he looks at you. I reckon he'd tryand snog you if he thought he could get away with it, dirty bugger.

TEGS: He reckons I want to kiss you.

RYAN: He what?

TEGS: He reckons that's why I said I'd meet you.

RYAN: He's mental.

TEGS: Yeah.

RYAN: He said that?

TEGS: Yeah.

RYAN: And what did you say?

TEGS: I told him I just want you to leave us alone.

TEGS pulls out JORDAN'S blade.

RYAN: What's the hell's that? Teggsy - what you doing?

TEGS: Sorting things out. How does it feel being the one who don't know what's gonna happen next? How's it feel?

RYAN: I dunno.

TEGS: You don't know?

RYAN: It feels...

TEGS: Go on, you can say it. It feels gay. As in crap. Say it! It feels gay. Say it!

RYAN makes a break for it.

RYAN: Sir!!!!

TEGS: *(Lunging.)* Ahhhhhhh!

TEGS goes for RYAN, who just dodges getting gored.

RYAN: Tegs, man...!

TEGS: *(Stabbing again.)* Ahhhhhh!

RYAN: Tegs!

JORDAN comes running up.

JORDAN: Tegs!

TEGS: Say it, you bastard! Say it! Say it!

TEGS is on top of RYAN about to stab downwards as JORDAN pulls him off.

JORDAN: Tegs!

TEGS is crying.

TEGS: Say it! You rotten bloody bastard! Say it!

JORDAN: Hey mate, it's alright, yeah? Shh...

JORDAN grabs crying TEGS and cradles him.

RYAN: I never touched him. He just went mental. He's got issues, man. ...Is he alright? Teggsy?

(Reaching out.)

Are you alright, man?

JORDAN: Don't touch him!

But RYAN does anyway. TEGS reaches out and grabs RYAN'S sleeve and pulls him in. RYAN finds himself uncomfortably-comfortably close to JORDAN and TEGGS. Uncertainly, RYAN strokes TEG'S hair, then kisses his head....

...just as ISAAC comes in. RYAN shoves TEGS and JORDAN away...

RYAN: Get off me you bloody pair of queers!

RYAN runs off past ISAAC.

ISAAC: You lot alright?

JORDAN: Sod off.

ISAAC: ...So Gay.

LORIS enters. Sees weeping TEGS in JORDAN'S arms. Looks at ISAAC.

LORIS: What you done?

ISAAC: Nothing! He tried to snog Ryan and he got knocked back and he's broken-hearted.

LORIS: Jordan, what happened?

(Crouching.)

Tegs? Tegs? What happened?

(To ISAAC.)

Fetch Ryan back here right now.

KARMEL and LEE arrive just as ISAAC is leaving.

LEE: Oy, what you done to him?

ISAAC: *(Exiting.)* Sod off!

KARMEL: Teggsy, babes, I'm sorry!

LORIS: Why what have YOU done?

KARMEL: I should have spoken up. I should have stuck up for you. I should have, I'm sorry.

LORIS: What are you on about, girl?

ISAAC and RYAN return.

LORIS: Right, Ryan. What happened?

Silence.

LORIS: Anybody. What happened? How are we supposed
to sort all this out, if no-one ever speaks? You're all
texting, tweetering and tweeting - but no one's talking and
nothing's getting sorted. Well - it's getting sorted today.
'Cause we are gonna wait here until someone speaks up
and says something. Here. As long as it takes.

And then - and only then. We can move.

Alright?

Long silence.

ISAAC: ...This is so gay.

MUSIC. CAST DANCE.

END

TEACHERS' NOTES

ENGLAND & WALES

Foreword

BEN SUMMERSKILL
CHIEF EXECUTIVE, STONEWALL

Stonewall is the national lesbian, gay and bisexual charity. We were set up in 1989 in response to Section 28, the legislation – now repealed – which stopped schools taking action against homophobic bullying, something which blights the lives not just of young people growing up to be gay but of countless others too.

Since our creation, we've lobbied, campaigned and inspired organisations to work with us to achieve equality for gay people at home, at work, and at school. Our Education for All campaign was established to help schools tackle homophobia. We work with government, local authorities, primary and secondary schools and youth organisations to tackle homophobic bullying.

In 2007 and 2008 we toured a new Theatre in Education production, *FIT*, to 75 secondary schools across Britain. Seen by 20,000 students, the play highlighted the fact that young people welcome the opportunity to discuss discrimination, relationships and sexual orientation and to challenge each other's views. Teachers we met during the tour told us that they want to talk about these issues in the classroom but a lack of appropriate resources and materials made this impossible.

We hope that this film adaptation of *FIT* will now make that possible and will enable all young people to achieve their full potential.

Note from Sir Ian McKellen

Having visited a number of secondary schools across the country, I have seen first hand not only the damage that homophobic bullying can do to young people, but also how giving them the opportunity to discuss sexual orientation and difference can help create inclusive school environments where every young person can be themselves. I hope that *FIT* will

help you and your school to tackle homophobia and ensure that all young people can enjoy learning free from bullying.

What is Fit?

Fit, by Rikki Beadle-Blair, is an intelligent, powerful and entertaining film that tackles the issue of homophobic bullying in a culture where everything from not liking sport to wearing the wrong trainers is "gay". It has been developed to help tackle homophobic bullying in Britain's schools. The film has been especially created for Key Stage 3 and 4 students, and specifi cally complements various learning objectives from the National Curriculum, particularly PHSE and Citizenship but also including Performing Arts and English. FIT is a film based on a Theatre in Education tour commissioned by Stonewall which in 2007 and 2008 toured to over 75 secondary schools across Britain and was seen by over 20,000 Key Stage 3 and 4 students.

More information about the film can be found at www.stonewall.org.uk/fit

Stonewall is the national lesbian, gay and bisexual charity. Renowned for its lobbying and campaigning, successes include the repeal of Section 28 and the introduction of civil partnerships. Education for All is Stonewall's campaign to tackle homophobic bullying in schools, and has produced resources such as Spell It Out, a teacher training DVD on how to tackle homophobia in schools, our Some People Are Gay: Get over it! materials, as well as national research the *School Report* and *The Teachers' Report*, government guidance on homophobic bullying and curriculum materials.

For more information visit www.stonewall.org.uk/ educationforall

What is homophobic bullying?

Homophobic bullying is motivated by prejudice against lesbian, gay or bisexual people, or against those thought to be lesbian, gay or bisexual. It is also often experienced by young people who are seen to be "different" in some other way – for example, boys who do not "act like the other boys" or girls who do not "act like girls". A person's identity may be used to abuse them and homophobic bullying can therefore be experienced by all pupils, regardless of their sexual orientation.

Teachers and school staff are most likely to see, and be in a position to respond to, incidents of homophobic bullying. Schools have a legal duty to prevent and respond to all forms of bullying including homophobic bullying, as well as create environments of respect for others and good behaviour.

Homophobic bullying can cause lasting damage to the self-esteem, happiness and well-being of the children and young people who experience it. A school where any bullying is tolerated creates an unsafe learning and teaching environment for all. It is important that all school staff – as well as young people – are involved in a school's approach to addressing bullying.

To find out more about the resources available to help your school to tackle homophobic bullying visit www.stonewall. org.uk/educationforall

Homophobia and homophobic bullying: the facts

Homophobic bullying is endemic in Britain's schools. Almost two thirds (65%) of lesbian, gay and bisexual young people have experienced direct bullying. 75% of young gay people attending faith schools have experienced homophobic bullying.

98% of young gay people hear the phrases "that's so gay" or "you're so gay" in school, and over four fifths hear such comments often or frequently. 95% of teachers hear such comments.

97% of pupils hear other insulting homophobic remarks, such as "poof", "dyke", "rug-muncher", "queer" and "bender". Over seven in ten gay pupils hear those phrases used often or frequently. 80% of teachers hear such comments.

Lesbian, gay and bisexual young people say that they experience verbal abuse. Over two in five have experienced cyberbullying, 41% have experienced physical abuse, one in eight have been threatened with a weapon and one in six have been subjected to death threats.

Nine in ten secondary school staff say that young people – regardless of their sexual orientation – experience homophobic bullying.

75% of teachers who witness homophobic bullying say that it is pupils who are suspected of being lesbian, gay or bisexual who are most likely to experience homophobic bullying followed by boys who behave or act like girls.

Secondary school teachers say that homophobic bullying is the most frequent form of bullying after bullying because of weight.

Nine in ten secondary school staff believe lesbian and gay issues should be addressed through the curriculum.

The School Report – The experiences of young gay people in Britain's schools

The Teachers' Report – Homophobic bullying in Britain's schools

www.stonewall.org.uk/educationforall

How to use this resource

FIT tells the individual stories of six young people – Lee, Karmel, Tegs, Jordan, Isaac and Ryan – who think that all they have in common is dancing. The story follows them as they battle through a minefield of exploding hormones, awakening feelings and homophobia as they attempt to fit in, stand out, discover their own identities and accept each other.

FIT can be watched as a feature film or used in the classroom as individual stories to explore and discuss a range of themes and issues with students at Key Stages 3 and 4. The DVD also contains a series of video diaries, giving students the opportunity to listen to the characters talking more in-depth about their feelings and the situation they are facing.

This pack that accompanies the DVD highlights the main themes in each of the individual stories and suggests questions to consider when preparing lessons to accompany the film. These themes should complement the work that schools are already doing in PSHE and Citizenship classes, but may also be useful as part of the English Literature and Performing Arts and other areas of the curriculum.

More information on the national curriculum can be found at www.qcda.gov.uk/curriculum

FIT also complements guidance for schools published by the DCSF on how to tackle homophobic bullying. The guidance also contains an overview of government legislation and policy with regard to promoting the welfare of pupils and protecting them from homophobic bullying, as well as links to useful resources and information.

www.stonewall.org.uk/guidance or www.teachernet.gov.uk

Further information about FIT, including lesson plans to accompany the film, is available on Stonewall's website. Visit www.stonewall.org.uk/fit to find out more.

Name: Lee

Age: 17

Hobbies: basketball, street dance, graffiti art, Joelly D the popstar, karaoke

Lee's commitment to Karmel as a best friend is undeniable. But when she discovers that Karmel is keeping the fact that she's a lesbian secret, she feels hurt and abandoned. Her own non-conformity also creates conflict with her brothers, who would like her to dress and look more like they would expect a girl to.

At *Key Stage 3* students should be learning about "different and shared needs, abilities and membership of groups" and recognise that "culture, including the language, ideas, customs and traditions practised by people within a group, also forms part of identity".

Lee's story focuses on themes of *gender stereotyping* and *friendship*. Use Lee's story in PSHE and Citizenship classes to discuss the following questions:

- Why do people think Lee is a lesbian?
- Is Lee a stereotypical girl? What kind of "girl" do we see her as?
- What is a stereotype?
- Do you think Lee minds not fitting in? What makes her so proud of who she is?
- How does Lee feel when she finds out her best friend is keeping a secret from her?
- How important is family to Lee? How do we show people we love them?
- What would you do if you found out your best friend was gay?
- Why does Lee think Karmel will fancy her? Can Karmel be trusted to just be her friend?
- How should boys and girls "act" or "behave"?
- How do we react when boys don't "act" like boys or girls don't "behave" like girls?

Additional information

Girl Guides UK produces an annual *Girls' Attitudes* survey – a comprehensive study of the views and opinions of girls aged 7-21 across the UK. http://girlsattitudes.girlguiding.org.uk

PinkStinks is a campaign and social enterprise that challenges the culture of pink in girls' lives. www.pinkstinks.co.uk

Name: Karmel

Age: 17

Hobbies: fashion, shopping, beauty, drama, street dance

Karmel is the popular girl. No one suspects she might be gay and pressure from her parents makes it hard for Karmel to admit to herself – let alone to anyone else – that she is a lesbian. Despite trying to prove to herself that she is "normal", Karmel finds support at a local youth group and in Lee, and learns that she's not alone.

Karmel's story addresses the issues of *coming out*, as well as the *impact of homophobic language*.

The PSHE national curriculum at *Key Stage 3* should include discussion of 'a wide range of relationships, such as boy/girl [and] same sex...' as well as prejudice, bullying and discrimination. Use Karmel's story during lesson time to discuss the following questions:

- **Why do you think Karmel hasn't told her friends and family she's a lesbian?**
- **Why does Karmel get upset about people saying "that's so gay"?**
- **Does language hurt? Is "gay" just a word?**
- **What do you think of Karmel's parents? How do you think her dad's attitude towards gay people affects Karmel and her relationship with them?**
- **Were you surprised to find out that Karmel is a lesbian? Why? Why do we assume that lesbians look a certain way? Does the media stereotype lesbians?**
- **Why do you think Karmel went on a date with Tyler? Do you think maybe she is bisexual?**
- **Do we feel under pressure to have a boyfriend or a girlfriend? Why do you think people often find it hard to tell their friends and family that they're gay? Could we tell people in this school? Is it OK to say "that's so gay" here?**
- **Why do gay people feel a need to "come out"? Why don't heterosexual people "come out"? Do we always assume people are straight?**

Additional information

Stonewall's Challenging Homophobic Language Education Guide provides information for schools on why and how to address the use of phrases such as "you're so gay" and "that's so gay". www.stonewall.org.uk/resources

Channel 4's Gay to Z series has information about real-life coming out experiences. Visit www.channel4.com/programmes/gay-to-z for more information.

Name: Tegs

Age: 17

Hobbies: reading, online gaming, indie rock, street dance, tap dancing

Tegs finds it hard to fit in. An expert tap dancer, he is singled out as different and subjected to bullying – physical, verbal and mental – by others who suspect him of being gay. His friendship with Jordan encounters difficulties when Jordan makes his true feelings for Tegs known. But when Tegs discovers the weakness of one of the bullies and starts dating Molly he begins to find more confidence in himself.

Tegs's story addresses themes of *difference* and *different forms of bullying*.

Schools have a duty to ensure the wellbeing of all young people, and this includes tackling all forms of bullying. As part of the PSHE curriculum at *Key Stage 3*, use Tegs's story to get students thinking about different forms of bullying.

- What sort of person is Tegs? Why is he so shy?
- Why does Tegs like Jordan so much? Do you think Tegs fancies Jordan?
- What different forms of bullying is Tegs experiencing?
- Why do you think he's being bullied?
- How can Tegs challenge bullying? What options are available to him? Why does he decide not to use a knife?
- What should be done to stop the bullying?
- Do we think bullying happens at our school?
- What is our school doing to tackle bullying?
- Is it OK for boys to be professional dancers? And for girls to play football?
- How should boys act? How should girls act?

Additional information

The DCSF has published guidance for schools on how to tackle homophobic bullying.

For more information visit www.stonewall.org.uk/guidance or www.teachernet.gov.uk

Name: Jordan

Age: 17

Hobbies: football, MCing, street dance, boxing

Adopted, black, the budding footballer – Jordan is proud of who he is. But his path to a successful football career might be jeopardised by the fact that he's gay – something he hasn't yet told his friends and family. His friendship with Tegs takes an initial turn for the worse when he plucks up the courage to tell him he loves him.

Jordan's story addresses *homophobia in sport* and *perceptions of gay people*.

Jordan's story should be used as part of the Citizenship curriculum at *Key Stage 4* to discuss "the changing nature of UK society, including the diversity of ideas, beliefs, cultures, identities, traditions, perspectives and values that are shared".

- **Do you think Jordan should keep quiet about being gay? Do you think his sexual orientation will affect his career?**
- **What do you think about his parents' reaction when he tells them he's gay? Why does Jordan cry when he comes out to his parents?**
- **How do you think his brother Linus is feeling? How might their relationship change after he has come out?**
- **How is Jordan's family different or similar to yours? Do we all come from different families?**
- **Why do you think so few high-profile sportspeople are openly gay?**
- **Can athletes or entertainers be gay?**
- **Is it OK for premiership footballers to be openly gay? Would we feel differently about them if they were?**
- **How would you feel if your best friend told you they loved you?**

Additional information

Use statistics from Stonewall's 2009 research, **Leagues Behind**, which explores football's failure to tackle anti-gay abuse, as part of discussions on homophobia in sport. www.stonewall.org.uk/documents/leagues_behind. pdf

Name: Isaac

Age: 18

Hobbies: rollerblading, PlayStation, collecting baseball caps, street dance, hip-hop and ragga music

Isaac's friendship with Ryan goes back a long way: they've been through school together and they've got into trouble together – their dads even learned to speak English together. But when Isaac finds out Ryan is gay, his confusion and anger cause him to lash out at his best friend.

Isaac's story explores *prejudice* and *discrimination*, especially homophobia.

Through the Citizenship curriculum at *Key Stage 4* students should explore "issues relating to social justice, human rights, community cohesion and global interdependence" and "challenge injustice, inequalities and discrimination." Use Isaac's story to discuss questions such as:

- Why do you think Isaac holds such negative attitudes towards gay people?
- Do you think he really means it? How would this make Ryan feel?
- Why does Isaac get so angry when he finds out Ryan is gay? Has Ryan let him down by lying to him?
- Why does Isaac talk about AIDS and child abuse when discussing homosexuality? Why do we hold certain stereotypes about gay people?
- What do you think about Isaac's home life? Why do you think he fights with his dad so much? Do you think this affects his behaviour with his friends?
- Does homophobia still exist in society today? What does it look like?
- How has the law changed in recent years to ensure equality for gay people?
- How does gay equality in the United Kingdom compare with other countries of the world?
- Can we be different and still get along?

Additional information

As part of a discussion on attitudes towards minority groups and discrimination in today's society use Stonewall's 2008 research, *Homophobic Hate Crime: the Gay British Crime Survey 2008* which explores lesbian, gay and bisexual people's experiences of homophobic hate crimes.

As part of drug, alcohol and tobacco education at Key Stage 4, you may also want to discuss Isaac, Ryan and Charlie's alcohol consumption and the impact that this has on their friendship and behaviour. www.stonewall.org.uk/resources

Name: Ryan

Age: 18

Hobbies: football, martial arts, RnB, singing, PlayStation, sci-fi, street dance

Ryan likes to be one of the lads. And when he gets together with his friends Isaac and Charlie, anyone could be their next target of bullying and teasing. But when it comes to Tegs, there are hidden motives for Ryan's homophobic behaviour. As he comes to terms with his own sexual orientation – and his friends find out – Ryan ends up on the receiving end of violence.

Ryan's story addresses issues of *friendship*, *secrecy* and *denial*. Through the *Key Stage 4* PSHE curriculum students should understand "that self-esteem can change with personal circumstances, such as those associated with family and friendships". Use this story to discuss the following questions:

- What do you think of Ryan's friendship with Charlie and Isaac? Do you think he can trust them?
- Why do you think Ryan is bullying Tegs? Is he trying to deny his feelings? Does he want to be physically closer to Tegs?
- Can Ryan and Isaac be friends again?
- What could Charlie do to help?
- Should Ryan tell someone that Isaac beat him up? Why hasn't he?
- Does Ryan's sister know that he is gay? Why doesn't Ryan talk to her about it? Who can he talk to?
- Who can you talk to about your problems?

Additional information

Compare statistics from Stonewall's groundbreaking national research, The School Report with data from our 2009 survey, The Teachers' Report, to examine the differences between lesbian, gay and bisexual young people's perceptions of homophobic bullying at school and that of their teachers. Why do you think young people report more bullying than teachers see? www.stonewall.org.uk/educationforall

Ten things your school can do to prevent homophobic bullying

1 Acknowledge and identify the problem

Schools should acknowledge that homophobic bullying occurs in schools and take appropriate steps to prevent and respond to it by monitoring homophobic bullying incidents and responding to them when they happen.

2 Develop policies with young people

Schools' anti-bullying policies should include homophobic bullying. Young people should be involved in the development of these policies, which should be displayed prominently in schools. All staff and young people should be informed of these policies.

3 Promote a positive social environment

Schools should ensure staff challenge all use of homophobic language to send a clear message that homophobic language and bullying are unacceptable.

4 Address staff training needs

Schools should ensure that staff receive training to help them respond to, and prevent, homophobic bullying and to support lesbian, gay and bisexual pupils. Training should include an understanding of homophobic bullying and how it affects young people, as well as practical ways to respond to and prevent homophobic bullying from occurring.

5 Provide information and support

Schools should ensure that pupils have access to support and information by, for example, making resources available in school libraries and ensuring internet access to safe websites. Schools should also ensure that young people feel comfortable and confident to ask school staff for support and advice.

6 Integrate sexual orientation into the curriculum

Try to integrate teaching about sexual orientation into the curriculum as a whole. Identify lesbian and gay people both formally, in what is taught, and informally, in posters, assemblies etc. Stonewall's teachers' packs will be helpful.

7 Use outside experience

Schools should work with external bodies such as Stonewall's Education Champions Programme, gay charities, local youth workers or local authorities who can help schools tackle homophobic bullying and offer support to individuals.

8 Encourage role models

Positive role models help reduce bullying, provide support and make young people feel more confident and comfortable. Schools should ensure that gay members of staff feel comfortable and supported to be open about their sexual orientation. Teachers who are gay are in a strong position to fulfil this role provided they are supported by their schools.

9 Don't make assumptions

Schools should know, where possible, the backgrounds of their students, remembering that everyone and every family is different and that many young people will have gay family members and friends.

10 Celebrate achievements

Acknowledge and celebrate progress so that parents, governors, pupils and staff understand and are aware of the progress being made in the school's efforts to tackle homophobia.

Further resources and information

The following list highlights key sources of support for school staff to challenge homophobic bullying and support lesbian, gay and bisexual young people.

→ Stonewall's **Education for All** programme provides information, resources, support and guidance on how to challenge homophobia and creative inclusive school environments where all young people can learn free from bullying. **For more information visit www.stonewall.org.uk/educationforall**

→ Stonewall's **Youth Volunteering Programme** helps young people create campaigns to tackle homophobic bullying in their local schools, colleges and communities. **For more information visit www.stonewall.org.uk/ youthvolunteering**

→ Is your local authority an Education Champion? Find out if your local authority is working with Stonewall's **Education Champions Programme** to tackle homophobic bullying in local schools at **www.stonewall.org.uk/educationchampions**

→ Safe to Learn: Homophobic bullying (DCSF): government guidance for schools on tackling homophobic bullying is available at **www.stonewall.org.uk/guidance** or **www.teachernet. gov.uk**

→ **LGBT History month** gives schools the opportunity to learn about the histories of lesbian, gay, bisexual and transgender people. **www.lgbthistorymonth.org.uk**

→ The Anti-Bullying Alliance is an alliance of over 60 organisations working to stop bullying and create safer environments in which children and young people can live, grow, play and learn. **www. anti-bullyingalliance.org.uk**

→ **ChildLine 0800 1111** is a free helpline for children and young people in the UK.

→ Gendered Intelligence is an organisation which supports young transgender people and other young people experiencing issues with their gender identity. **www.genderedintelligence.co.uk**

TEACHERS' NOTES

SCOTLAND

Foreword

CARL WATT, DIRECTOR
STONEWALL SCOTLAND

Stonewall Scotland is a national lesbian, gay, bisexual and transgender charity. Part of the GB-wide charity Stonewall, Stonewall Scotland was founded in 2000, the year Section 28 (also known as section 2A) was repealed in Scotland – a piece of legislation which stopped schools tackling homophobic bullying. Since then we have lobbied, campaigned and inspired organisations throughout Scotland to work with us to achieve equality and to challenge prejudice in Scottish society at home, at school and at work.

Our Education for All campaign was set up to help schools tackle homophobia. Working with Scottish Government, local authorities, schools and youth organisations we strive to prevent homophobia and create cultures where young people can be themselves – regardless of their sexual orientation. In 2007 and 2008 Stonewall's Theatre in Education production, *FIT*, was seen by 20,000 students in 75 secondary schools across Britain, including eight schools in Scotland. The response to the play showed us that young people welcomed the opportunity to discuss discrimination, relationships and sexual orientation and to challenge each other's views – and that attending teachers wanted to talk about these issues in the classroom, but a lack of resources and materials made this impossible.

This feature film adaptation of *FIT* will help schools talk about homophobia and homophobic bullying. It will also support lesbian, gay, and bisexual students to feel they are valued members of the school community and help make school life a safer and happier learning environment for all young people.

Note from Sir Ian McKellen

Having visited a number of secondary schools across the country, I have seen first hand not only the damage that homophobic bullying can do to young people, but also how giving them the opportunity to discuss sexual orientation and difference can help create inclusive school environments where every young person can be themselves. I

hope that *FIT* will help you and your school to tackle homophobia and ensure that all young people can enjoy learning free from bullying.

What is Fit?

FIT by Rikki Beadle-Blair is an intelligent, powerful and entertaining film that tackles the issue of homophobic bullying in a culture where everything from not liking sport to wearing the wrong trainers is "gay". It has been developed to help tackle homophobic bullying in Britain's schools. Using this film could help Scottish schools meet a wide range of experiences and outcomes in the third, fourth and senior phase of Curriculum for Excellence and sits well with the Health and Wellbeing curriculum area.

As mentioned in the foreword, *FIT* is a film based on a Theatre in Education tour commissioned by Stonewall which in 2007 and 2008 toured secondary schools across Britain.

More information about the film can be found at www. stonewallscotland.org.uk/fit

Stonewall Scotland works for lesbian, gay, bisexual and transgender equality, lobbying and campaigning for equality across Scotland. Stonewall Scotland was set up in 2000 in response to requests from Scottish Stonewall supporters after devolution. We work with our GB offi ce, the Scottish Government, other Scottish national organisations, local authorities and businesses towards equality.

Education for All is Stonewall's campaign to tackle homophobic bullying in schools, and has produced resources such as Spell It Out, a teacher training DVD on how to tackle homophobia in schools, our Some People Are Gay: Get Over It! materials, as well as national research *The School Report* and *The Teachers' Report*.

For more information visit www.stonewall.org.uk/educationforall

What is homophobic bullying?

Homophobic bullying is motivated by prejudice against lesbian, gay or bisexual people, or against those thought to be lesbian, gay or bisexual. It is also often experienced by young people who are seen to be "different" in some other way – for example, boys who do not "act like the other boys" or girls who do not "act like girls". A person's identity may be used to abuse them and homophobic bullying can therefore be experienced by all pupils, regardless of their sexual orientation.

Teachers and school staff are most likely to see, and be in a position to respond to, incidents of homophobic bullying. By creating environments of respect for others and responding quickly and effectively to homophobic bullying, schools can affect both the impact and the rate of homophobic bullying. Under Curriculum for Excellence, learning through health and wellbeing promotes confidence, independent thinking and positive attitudes and dispositions. Because of this, it is the responsibility of every teacher to contribute to learning and development in this area. (www.ltscotland.org.uk/curriculumforexcellence/responsibilityofall/healthandwellbeing/principlesandpractice/index.aspprinciplesandpractice/)

Homophobic bullying can cause lasting damage to the self-esteem, happiness and well-being of the children and young people who experience it and impacts also on those who witness it. The feature film *FIT* will help you create a safe learning and teaching environment for all, bringing significant benefits to the culture, ethos and values of your school. It is important that all school staff – as well as young people – are involved in a school's approach to addressing bullying.

To find out more about the resources available to help your school to tackle homophobic bullying visit www.stonewall.org.uk/educationforall

Homophobia and homophobic bullying: the facts

Stonewall's publication, *The School Report* (2007), presents research into the experiences of young gay people in Britain's schools. *The Teachers' Report* (2009) shows teachers' experiences of homophobic bullying in Britain's schools.

Both reports can be downloaded from www.stonewall.org.uk/ educationforall

Below are some findings:

Homophobic bullying is endemic in Britain's schools. 65% of young lesbian, gay and bisexual pupils have experienced direct bullying. 75% of young gay people attending faith schools have experienced homophobic bullying.

98% of young gay people hear the phrases "that's so gay" or "you're so gay" in school, and over 80% hear such comments frequently. 95% of teachers hear such comments.

97% of pupils hear other insulting homophobic remarks, such as "poof", "dyke", "rug-muncher", "queer" and "bender". Over 70% of gay pupils hear those phrases used often or frequently. 80% of teachers hear such comments.

Lesbian, gay and bisexual young people say that they experience verbal abuse. Over 40% have experienced cyberbullying, 41% have experienced physical abuse, over 12% have been threatened with a weapon and 16% have been subjected to death threats.

90% of secondary school staff say that young people experience homophobic bullying regardless of their sexual orientation.

75% of teachers who witness homophobic bullying say that it is pupils who are suspected of being lesbian, gay or bisexual who are most likely to experience homophobic bullying followed by boys who behave or act like girls.

Secondary school teachers say that homophobic bullying is the most frequent form of bullying after bullying because of weight.

90% of secondary school staff believe lesbian and gay issues should be addressed through the curriculum.

How to use this resource

FIT tells the individual stories of six young people – Lee, Karmel, Tegs, Jordan, Isaac and Ryan – who think that all they have in common is dancing. The story follows them as they battle through a minefield of exploding hormones, awakening feelings and homophobia as they attempt to fit in, stand out, discover their own identities and accept each other.

FIT can be watched as a feature film or used in the classroom as individual stories to explore and discuss a range of themes and issues with students at Key Stages 3 and 4. The DVD also contains a series of video diaries, giving students the opportunity to listen to the characters talking more in-depth about their feelings and the situation they are facing.

This pack that accompanies the DVD highlights the main themes in each of the individual stories and suggests questions to consider when preparing lessons to accompany the film. These themes should complement the work that schools are already doing in PSHE and Citizenship classes, but may also be useful as part of the English Literature and Performing Arts and other areas of the curriculum.

More information on the experiences and outcomes in Curriculum for Excellence can be found on the Learning and Teaching Scotland website www.ltscotland.org.uk/curriculumforexcellence

Use of this resource can be supported further with the Toolkit for Teachers: Dealing with Homophobia and Homophobic Bullying in Scottish Schools, published in 2009 on the Learning Teaching Scotland website. The toolkit also contains an overview of the government legislation and policy with regard to promoting the welfare of pupils and protecting them from homophobic bullying, as well as links to useful resources and information.

Further information about FIT is available on Stonewall Scotland's website.
Visit www.stonewallscotland.org.uk/fit to find out more, including information on receiving training on how to use this resource.

Name: Lee

Age: 17

Hobbies: basketball, street dance, graffiti art, Joelly D the popstar, karaoke

Lee's commitment to Karmel as a best friend is undeniable. But when she discovers that Karmel is keeping the fact that she's a lesbian secret, she feels hurt and abandoned. Her own non-conformity also creates conflict with her brothers, who would like her to dress and look more like they would expect a girl to.

Lee's story focuses on themes of gender stereotyping and friendship.

Suggested questions for discussion:

- Why do people think Lee is a lesbian?
- Is Lee a stereotypical girl? What kind of "girl" do we see her as?
- What is a stereotype?
- Do you think Lee minds not fitting in? What makes her so proud of who she is?
- How does Lee feel when she finds out her best friend is keeping a secret from her?
- How important is family to Lee? How do we show people we love them?
- What would you do if you found out your best friend was gay?
- Why does Lee think Karmel will fancy her? Can Karmel be trusted to just be her friend?
- How should boys and girls "act" or "behave"?
- How do we react when boys don't "act" like boys or girls don't "behave" like girls?

Additional information

Girl Guides UK produces an annual *Girls' Attitudes* survey – a comprehensive study of the views and opinions of girls aged 7-21 across the UK. http://girlsattitudes.girlguiding.org.uk

PinkStinks is a campaign and social enterprise that challenges the culture of pink in girls' lives. www.pinkstinks.co.uk

Name: Karmel

Age: 17

Hobbies: fashion, shopping, beauty, drama, street dance

Karmel is the popular girl. No one suspects she might be gay and pressure from her parents makes it hard for Karmel to admit to herself – let alone to anyone else – that she is a lesbian. Despite trying to prove to herself that she is "normal", Karmel finds support at a local youth group and in Lee, and learns that she's not alone.

Karmel's story addresses the issues of *coming out*, as well as the *impact of homophobic language*.

Suggested questions for discussion:

• Why do you think Karmel hasn't told her friends and family she's a lesbian?

• Why does Karmel get upset about people saying "that's so gay"?

• Does language hurt? Is "gay" just a word?

• What do you think of Karmel's parents? How do you think her dad's attitude towards gay people affects Karmel and her relationship with them?

• Were you surprised to find out that Karmel is a lesbian? Why? Why do we assume that lesbians look a certain way? Does the media stereotype lesbians?

• Why do you think Karmel went on a date with Tyler? Do you think maybe she is bisexual?

• Do we feel under pressure to have a boyfriend or a girlfriend? Why do you think people often find it hard to tell their friends and family that they're gay? Could we tell people in this school? Is it OK to say "that's so gay" here?

• Why do gay people feel a need to "come out"? Why don't heterosexual people "come out"? Do we always assume people are straight?

Additional information

Stonewall's Challenging Homophobic Language Education Guide provides information for schools on why and how to address the use of phrases such as "you're so gay" and "that's so gay". Order a copy at www.stonewallscotland.org.uk/resources

Channel 4's *Gay to Z* series has information about real-life coming out experiences, amongst other real-life stories which you may find useful when discussing other themes that emerge throughout this film. Each episode lasts around 25 minutes. Visit www.channel4.com/programmes/gay-to-z for more information.

Name: Tegs

Age: 17

Hobbies: reading, online gaming, indie rock, street dance, tap dancing

Tegs finds it hard to fit in. An expert tap dancer, he is singled out as different and subjected to bullying – physical, verbal and mental – by others who suspect him of being gay. His friendship with Jordan encounters difficulties when Jordan makes his true feelings for Tegs known. But when Tegs discovers the weakness of one of the bullies and starts dating Molly he begins to find more confidence in himself.

Tegs's story addresses themes of *difference* and *different forms of bullying*.

Suggested questions for discussion:

- What sort of person is Tegs? Why is he so shy?
- Why does Tegs like Jordan so much? Do you think Tegs fancies Jordan?
- What different forms of bullying is Tegs experiencing?
- Why do you think he's being bullied?
- How can Tegs challenge bullying? What options are available to him? Why does he decide not to use a knife?
- What should be done to stop the bullying?
- Do we think bullying happens at our school?
- What is our school doing to tackle bullying?
- Is it OK for boys to be professional dancers? And for girls to play football?
- How should boys act? How should girls act?

Additional information

Toolkit for Teachers: Dealing with Homophobia and Homophobic Bullying in Scottish Schools

This toolkit was published in 2009, the resource was funded by the Scottish Government and developed by LGBT Youth Scotland in partnership with Learning and Teaching Scotland. It has helpful lesson plans and practical guidance for teachers on addressing homophobic bullying in the classroom. www.ltscotland.org.uk/homophobicbullyingtoolkit

respectme

respectme is Scotland's anti-bullying service and gives information on different forms of bullying. They have publications and resources to help teachers tackle bullying. www.respectme.org.uk

Name: Jordan

Age: 17

Hobbies: football, MCing, street dance, boxing

Adopted, black, the budding footballer – Jordan is proud of who he is. But his path to a successful football career might be jeopardised by the fact that he's gay – something he hasn't yet told his friends and family. His friendship with Tegs takes an initial turn for the worse when he plucks up the courage to tell him he loves him.

Jordan's story addresses *homophobia in sport* and *perceptions of gay people*.

Suggested questions for discussion:

- **Do you think Jordan should keep quiet about being gay? Do you think his sexual orientation will affect his career?**
- **What do you think about his parents' reaction when he tells them he's gay? Why does Jordan cry when he comes out to his parents?**
- **How do you think his brother Linus is feeling? How might their relationship change after he has come out?**
- **How is Jordan's family different or similar to yours? Do we all come from different families?**
- **Why do you think so few high-profile sportspeople are openly gay?**
- **Can athletes or entertainers be gay?**
- **Is it OK for premiership footballers to be openly gay? Would we feel differently about them if they were?**
- **How would you feel if your best friend told you they loved you?**

Additional information

Use statistics from Stonewall's 2009 research, *Leagues Behind*, which explores football's failure to tackle anti-gay abuse, as part of discussions on homophobia in sport.

www.stonewall.org.uk/documents/leagues_behind.pdf

Toolkit for Teachers: Dealing with Homophobia and Homophobic Bullying in Scottish Schools has useful links to news articles covering homophobia in sport (page 75 of the toolkit).

www.ltscotland.org.uk/homophobicbullyingtoolkit

Name: Isaac

Age: 18

Hobbies: rollerblading, PlayStation, collecting baseball caps, street dance, hip-hop and ragga music

Isaac's friendship with Ryan goes back a long way: they've been through school together and they've got into trouble together – their dads even learned to speak English together. But when Isaac finds out Ryan is gay, his confusion and anger cause him to lash out at his best friend.

Isaac's story explores *prejudice* and *discrimination*, especially homophobia.

Suggested questions for discussion:

- Why do you think Isaac holds such negative attitudes towards gay people?
- Do you think he really means it? How would this make Ryan feel?
- Why does Isaac get so angry when he finds out Ryan is gay? Has Ryan let him down by lying to him?
- Why does Isaac talk about AIDS and child abuse when discussing homosexuality? Why do we hold certain stereotypes about gay people?
- What do you think about Isaac's home life? Why do you think he fights with his dad so much? Do you think this affects his behaviour with his friends?
- Does homophobia still exist in society today? What does it look like?
- How has the law changed in recent years to ensure equality for gay people?
- How does gay equality in the United Kingdom compare with other countries of the world?
- Can we be different and still get along?

Additional information

As part of a discussion on attitudes towards minority groups and discrimination in today's society, use Stonewall's 2008 research, *Homophobic Hate Crime: the Gay British Crime Survey 2008* which explores lesbian, gay and bisexual people's experiences of homophobic hate crimes. www.stonewall.org.uk/publications

As part of drug, alcohol and tobacco education, you may also want to discuss Isaac, Ryan and Charlie's alcohol consumption and the impact that this has on their friendship and behaviour.

Name: Ryan

Age: 18

Hobbies: football, martial arts, RnB, singing, PlayStation, sci-fi, street dance

Ryan likes to be one of the lads. And when he gets together with his friends Isaac and Charlie, anyone could be their next target of bullying and teasing. But when it comes to Tegs, there are hidden motives for Ryan's homophobic behaviour. As he comes to terms with his own sexual orientation – and his friends find out – Ryan ends up on the receiving end of violence.

Suggested questions for discussion::

• What do you think of Ryan's friendship with Charlie and Isaac? Do you think he can trust them?

• Why do you think Ryan is bullying Tegs? Is he trying to deny his feelings? Does he want to be physically closer to Tegs?

• Can Ryan and Isaac be friends again?

• What could Charlie do to help?

• Should Ryan tell someone that Isaac beat him up? Why hasn't he?

• Does Ryan's sister know that he is gay? Why doesn't Ryan talk to her about it? Who can he talk to?

• Who can you talk to about your problems?

Additional information

Compare statistics from Stonewall's groundbreaking national research, *The School Report* with data from our 2009 survey, *The Teachers' Report*, to examine the differences between lesbian, gay and bisexual young people's perceptions of homophobic bullying at school and that of their teachers. Why do you think young people report more bullying than teachers see? *The School Report* (2007) www.stonewall.org.uk/schoolreport *The Teachers' Report* (2009) www.stonewall.org.uk/teachersreport

Ten things your school can do to prevent homophobic bullying

1 Acknowledge and identify the problem

Acknowledge that homophobic bullying occurs in schools and take appropriate steps to prevent and respond to it by monitoring homophobic bullying incidents and responding to them when they happen.

2 Develop policies with young people

Include homophobic bullying in anti-bullying policies and include young people in the development of these policies; these should be displayed prominently in schools. All staff and young people should be informed of these policies.

3 Promote a positive social environment

Ensure staff challenge all use of homophobic language to send a clear message that homophobic language and bullying are unacceptable.

4 Address staff training needs

Ensure that staff receive training to help them respond to, and prevent, homophobic bullying and to support lesbian, gay and bisexual pupils. Training should include an understanding of homophobic bullying and how it affects young people, as well as practical ways to respond to and prevent homophobic bullying from occurring.

5 Provide information and support

Ensure that pupils have access to support and information by, for example, making resources available in school libraries and ensuring internet access to safe websites. Ensure that young people feel comfortable and confident to ask school staff for support and advice.

6 Integrate sexual orientation into the curriculum

Try to integrate teaching about sexual orientation into the curriculum as a whole. Identify lesbian and gay people both formally, in what is taught, and informally, in posters, assemblies etc.

7 Use outside experience

Work with external bodies such as Stonewall Scotland and other agencies (see Further Resources and Information section for suggested agencies), local youth workers or local authorities who can help schools tackle homophobic bullying and offer support to individuals.

8 Encourage role models

Positive role models help reduce bullying, provide support and make young people feel more confident and comfortable. Schools should ensure that gay members of staff feel comfortable and supported to be open about their sexual orientation. Teachers who are gay are in a strong position to fulfil this role provided they are supported by their schools.

9 Don't make assumptions

Know the backgrounds of your students, remembering that everyone and every family is different and that many young people will have gay family members and friends.

10 Celebrate achievements

Acknowledge and celebrate progress so that parents, governors, pupils and staff understand and are aware of the progress being made in the school's efforts to tackle homophobia.

Further resources and information

The following list highlights key sources of support for school staff to challenge homophobic bullying and support lesbian, gay and bisexual young people.

Visit **www.stonewallscotland.org.uk/fit** for further support and information on using this resource. Stonewall Scotland also offers training around homophobic bullying and how to use this DVD. Please contact Stonewall Scotland's Education Team for more details: email **education@ stonewallscotland.org.uk** or telephone **0131 557 3679**

→ Stonewall's **Education for All** programme provides information, resources, support and guidance on how to challenge homophobia and creative inclusive school environments where all young people can learn free from bullying. **For more information visit www. stonewall.org.uk/educationforall**

→ **Toolkit for Teachers: dealing with Homophobia and Homophobic Bullying in Scottish Schools** was published in 2009, the resource was funded by the Scottish Government and developed by LGBT Youth Scotland in partnership with Learning and Teaching Scotland. It has helpful lesson plans and practical guidance for teachers on addressing homophobic bullying in the classroom:**www.ltscotland. org.uk/homophobicbullyingtoolkit**

→ **Learning and Teaching Scotland** For more information on Curriculum for Excellence in general, and for the experiences and outcomes achieved by using this DVD:

 www.ltscotland.org.uk

→ **respectme** is Scotland's anti-bullying service and gives information on different forms of bullying. It has publications and resources to help teachers tackle bullying: **www.respectme.org.uk**

→ **LGBT History month** gives schools the opportunity to learn about the histories of lesbian, gay, bisexual and transgender people. **www. lgbthistorymonth.org.uk**

→ The **Scottish Transgender Alliance** offers guidance to service providers and employers on transgender equality good practice in Scotland: **www.scottishtrans.org**

→ **Parents Enquiry Scotland** offers information and helplines for parents and families of lesbian, gay, bisexual or transgender people: **www.parentsenquiryscotland.org** or email **parentsenquiry@hotmail.com**

→ **ChildLine 0800 1111** is a free helpline for children and young people in the UK.